POSTCARD HISTORY SERIES

Little Bighorn

ON THE FRONT COVER. This Burlington Railroad postcard from the 1920s reprints a 1908 photograph by Richard Throssel of the three Crow scouts on the battlefield.

ON THE BACK COVER. This is a rare photograph by Jesamine Spear Johnson that shows surviving chiefs at the 50th anniversary of the battle on June 26, 1926.

Little Bighorn

To Carl & Dolly —
Fellow companions on the
Custer trail & faithful friends
in faith & life!

Vincent A. Heier

Vincent A. Heier
3/16/10

ARCADIA
PUBLISHING

Published by Arcadia Publishing
Charleston SC, Chicago IL, Portsmouth NH, San Francisco CA

Printed in the United States of America

Library of Congress Control Number: 2009921932

For all general information contact Arcadia Publishing at:
Telephone 843-853-2070
Fax 843-853-0044
E-mail sales@arcadiapublishing.com
For customer service and orders:
Toll-Free 1-888-313-2665

Visit us on the Internet at www.arcadiapublishing.com

*For my parents, who first encouraged my interest in history and in Custer,
and for the many friends with whom I have shared this journey over
the years.*

CONTENTS

ACKNOWLEDGMENTS

It is one thing to collect Custer and yet another to collect postcards. The postcards in this book are the result of my lifelong interest in George Armstrong Custer and his "last stand." I began collecting these postcards when I first visited the Little Bighorn battlefield in 1974. Over the years, I have expanded my collection through contacts with other collectors, postcard shows, and more recently EBay. I believe they represent a unique visual history of an event that continues to fascinate me to this day.

This book would not be possible without the help and encouragement of many good friends and historians. I am especially indebted to the following: Sandy Barnard, Greg Beuscher, Marilyn Bilyeu, Jim Brust, Tim Bumb, Joan Croy, John Doerner, Jim Donovan, Jim Eshelman, Dennis Fox, Richard Fox, Jerry Greene, Mike Koury, Bruce Liddic, Ed Lorden, Frank Mercatante, Murph Murphy, Bob Reece, Andy Roscoe, Wayne Sarf, Bob Snelson, Jill and Putt Thompson, Dick Upton, and Azuza Publishing of Englewood, Colorado.

INTRODUCTION

The postcard images in this book have their origin in the most famous battle of the American West. On June 25, 1876, the 7th Cavalry was on the move. Earlier that morning, scouts had reported to the 7th's commander, Lt. Col. George Armstrong Custer, that they had seen evidence of a large Native American village in the valley of the Little Bighorn in present-day southeastern Montana. As the soldiers approached the village, spirits were high, confident of victory.

Custer's 7th was but part of a larger campaign initiated by the government to force the return of the various bands of Lakota and Cheyenne, as well as other tribes, to the reservations. Gold had been discovered in the Black Hills in 1874, and the Native Americans were outraged by the government's response. The Fort Laramie Treaty of 1868 had given the Black Hills to the tribes, who considered it to be their sacred land. Unsuccessful in attempting to buy the Black Hills from the tribes, the government allowed miners to pour into the area. Lakota spiritual leader and chief Tatanka-Iyotanka, or Sitting Bull, remained defiant in this new threat to their traditional way of life.

The army decided to send three columns against the Native Americans: one under Gen. George Crook moved from Wyoming, another under Col. John Gibbon marched east from central Montana, and a third column under Gen. Alfred Terry left from present-day North Dakota. Accompanying Terry were the 12 companies of Custer's 7th Cavalry. After Terry's and Gibbon's commands converged on the Yellowstone River, a scouting report indicated a large Native American trail. Terry ordered Custer and the 7th to move down along the Rosebud Creek and swing south before striking the trail. Terry, with Gibbon's force, would move south and then west so as to block the Native Americans, who were presumed to be located in the vicinity of the Little Bighorn River.

Sitting Bull, who had received a vision of "soldiers falling into camp," continued to welcome various bands who gathered for common protection and religious ritual. On June 17, a large group of warriors had ridden to attack General Crook's command on the Rosebud. After a daylong fight, Crook withdrew back into Wyoming. Custer, Gibbon, and Terry were all unaware of Crook's strategic defeat. The biggest fear of each commander was that the Native Americans would break camp and escape.

Seeing increasing evidence of the very large Native American trail, Custer led his men into the valley of the Little Bighorn. He had intended to hide the command and attack the village on June 26, but further intelligence suggested that the Native Americans knew of his

presence. Custer decided to attack at once. He separated his troops, about 600 in all, into four parts. One company was ordered to protect the pack train (mules that carried the supplies and ammunition). Another three companies under Capt. Frederick Benteen were sent to scout the bluffs to the left of the trail, searching for scattered camps. Three companies under Maj. Marcus Reno were eventually ordered to cross the river to strike the village from the south. Custer and his remaining five companies moved north, presumably to flank the village.

The village they encountered was immense, with estimates of 7,000–8,000 people and including perhaps 2,000–3,000 warriors. Reno attacked but was driven into the woods along the river. Suddenly they retreated upon the bluffs, enduring heavy casualties. Benteen, not finding any Indians, returned to the main trail. He then received a message from Custer to "come on" quickly and move to bring up the packs. But when Benteen came upon Reno's desperate situation, he instead linked up with him. Hearing heavy firing farther north, they attempted to move the command, but warrior pressure caused the soldiers to fall back. Reno and Benteen then established a defensive position and held off the warriors for the rest of that day and throughout the next.

The question they began asking then is the same one asked today: "What happened to Custer?" Custer's movements after he sent his last message to Benteen remain a matter of intense historical scrutiny. Three days after the battle, scouts from General Terry discovered the mutilated and decomposing bodies of Custer's men. Some seemed to have been killed in a proper skirmish line. The positions of others on the field seemed to reflect a rout. At the farthest point on a ridge to the north, Custer and most of his headquarters staff made their last stand behind a breastwork of dead horses.

It took over a week for the news of Custer's defeat to reach the East, as citizens were in the midst of celebrating the centennial of the nation. The loss of Custer and his command was a terrible shock. Custer had been a Civil War cavalry general and a popular if controversial hero, and the 7th Cavalry in the popular mind was the best Indian-fighting regiment on the Plains.

After the battle, the various tribal bands separated. Some went back to the reservations. Others remained on the move to avoid the troops. Eventually Sitting Bull and his followers escaped into Canada. While the Battle of the Little Bighorn reflected their greatest moment of triumph on the Plains, it also proved to be the beginning of the end for their independence. The army pursued the Native Americans vigorously for the next two years. It was only a matter of time until most of their leaders, like Crazy Horse and even Sitting Bull, would surrender.

At first, the Battle of the Little Bighorn was seen in the national imagination as the heroic but desperate sacrifice of Custer and his men in the ongoing settlement of the West. The legend of "Custer's last stand" became a powerful and effective image for art, literature, film, television, and, as seen here, postcards.

Yet the battle also provoked a bitter political and military debate about who was to blame for the disaster. Over the next century and beyond, scholars and buffs have studied every facet of the event and its personalities. While this has stimulated much valuable research, it has also perpetuated many myths and falsehoods. Only in recent years, through the systematic study of archaeological data from the battlefield as well as a rereading of the various Native American accounts of the battle, has a new and better evaluation taken place.

Consequently, there has emerged a fuller understanding of the battle's conflicting role in American history when placed within the larger context of the treatment of the Native Americans then and now. This is most obviously demonstrated in the very name of the place, which originally was called by the government Custer Battlefield but now is named Little Bighorn Battlefield National Monument.

From the year after the event itself, the battlefield has become a site of visitation and commemoration. At first, under the jurisdiction of the War Department, it eventually became part of the National Parks System, where it remains today.

It is interesting to note that while George Armstrong Custer was one of the most photographed men of his day, there are no photographs of his last campaign. In fact, the first photograph of

the battlefield was not taken until July 1877 by John Fouch. His view "The Place Where Custer Fell" was lost until 1990.

Eventually other photographers followed. One, Stanley Morrow, did take pictures of a portion of General Crook's late-1876 campaign but did not visit the Custer Battlefield until 1879. His photographs, later widely distributed by another photographer, L. A. Huffman, often were printed as postcard views. Huffman himself did his own set of photographs at the 40th anniversary of the battle in 1916. He accompanied Gen. Edward Godfrey, a noted veteran of the battle, and historian–researcher Walter Camp in their explorations of the site. These too were published in postcard form.

Coffeen–Schnitger Trading Company of Sheridan, Wyoming, also distributed sets of "Custer Battle Souvenir Post Cards," borrowing some of these images. Another significant photographer was a Wyoming woman, Elsa Spear Byron. Her photographs of the 50th anniversary of the battle are well known. Also her sister Jessamine Spear Johnson made postcards from her own photographs at the anniversary.

Other noted photographers took views of the battle site, and many of these were made into postcards. Certainly the most prolific maker of postcard images was Kenneth Roahen. His real-photo postcards were done from the 1930s through the 1950s. More than anyone else, he captured the evolution of many sites on the battlefield. They make up a good part of the postcards reproduced in this book.

Postcards are often a visual memory of a special place and provide true snapshots of history. The purpose of this book then is to show how over the years the story has been preserved through such images, which, like paintings, sculptures, and movies, have enshrined the Battle of the Little Bighorn with legendary status.

One

ROAD TO CONFLICT

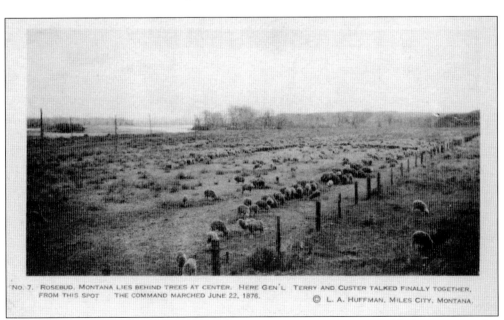

No. 7. ROSEBUD, MONTANA LIES BEHIND TREES AT CENTER. HERE GEN'L TERRY AND CUSTER TALKED FINALLY TOGETHER, FROM THIS SPOT THE COMMAND MARCHED JUNE 22, 1876. © L. A. HUFFMAN, MILES CITY, MONTANA.

On June 22, 1876, Lt. Col. George Armstrong Custer met with Gen. Alfred Terry near this spot for the last time. Terry had given Custer instructions to take the 7th Cavalry south along Rosebud Creek beyond the Native American trail unless Custer found "sufficient reason" to move toward the Native American village. The 12 companies of the 7th Cavalry passed in review on their ride into history.

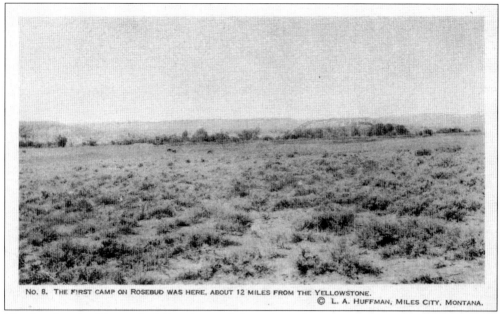

NO. 8. THE FIRST CAMP ON ROSEBUD WAS HERE, ABOUT 12 MILES FROM THE YELLOWSTONE.
© L. A. HUFFMAN, MILES CITY, MONTANA.

The first day, the 7th marched 12 miles south from the Yellowstone River and made their camp near this site. Here Custer summoned his officers to plan their attack.

NO. 9. SITE OF THE SECOND CAMP NEAR THE McRAE RANCH ON ROSEBUD.
© L. A. HUFFMAN, MILES CITY, MONTANA.

Riding 33 miles the next day, they reached this site. Along the way, the soldiers encountered the remnants of deserted Indian camps offering ominous warnings of what was to come.

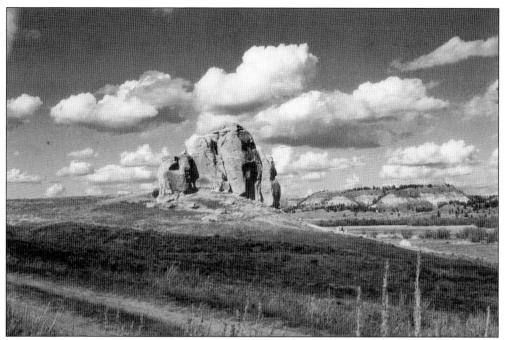

The Deer Medicine Rocks on Rosebud Creek are sacred to the Plains Indian tribes. This is considered the site of the Sun Dance of Lakota spiritual leader Sitting Bull. His vision of "soldiers falling into camp" became an omen for victory for the warriors.

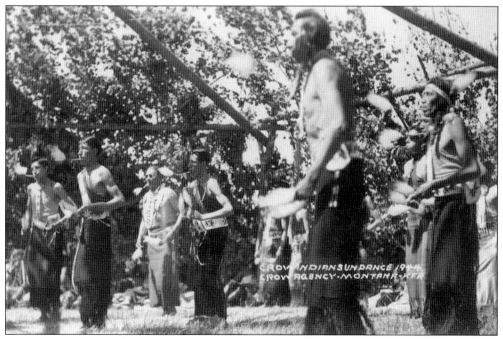

This more modern photograph by Ken Roahen shows a Crow Sun Dance. This spiritual ceremony, common to many of the Plains Indians, very often led to visions.

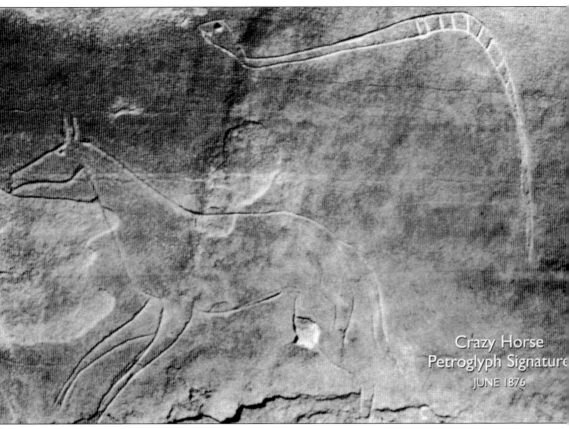

Crazy Horse
Petroglyph Signature
JUNE 1876

This horse with a lightening bolt on its hip is the only known signature of the famous Lakota warrior and chief known as Crazy Horse. He carved it in a sandstone cliff along what would become known as Reno Creek that leads to the Little Bighorn River. Located by Cheyenne historian John Stands in Timber and photographed in the 1960s by Glen Sweem, the carving was destroyed by weather and vandals.

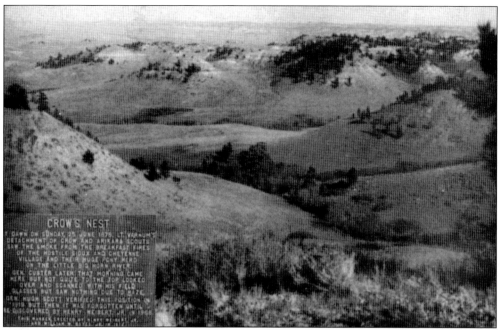

After another long march, scouts climbed to this high peak called Crow's Nest. At dawn on June 25, they saw signs of a huge Native American village near the Little Bighorn River. By the time Custer arrived, he could not see the village but believed the Native Americans were ahead and planned to attack June 26. Discovering that the Native Americans may have seen his column, he decided to attack immediately. In 1919, Gen. Hugh Scott and scout White Man Runs Him were photographed at this spot, but it was lost again until 1966 when found by rancher Henry Weibert.

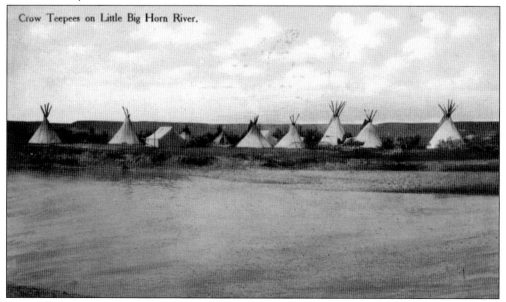

Crow Teepees on Little Big Horn River.

This 1912 view of Crow tepees along the Little Bighorn River is not unlike the sight eventually seen by Custer's soldiers on June 25, except there were seven camp circles for Lakota, Cheyenne, and Arapaho tribes numbering over 7,000 people with 2,000–3,000 warriors.

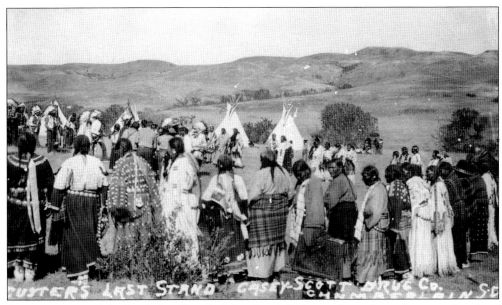

A reenactment of the battle in Chamberlain, South Dakota, shows how the many bands of Native Americans may have looked gathered in the village.

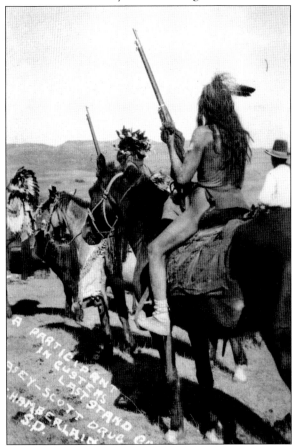

This battle reenactment photograph from Chamberlain, South Dakota, shows how the mounted warriors might have looked.

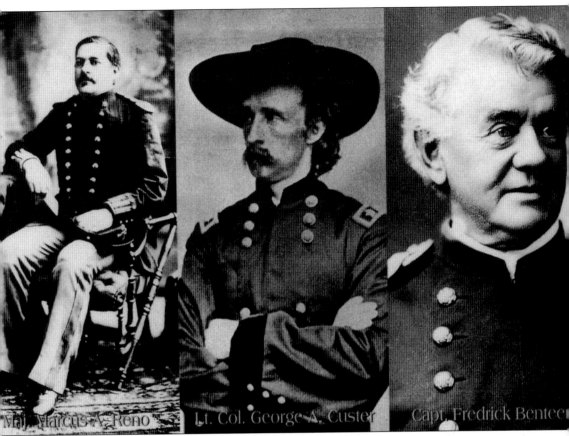

Maj. Marcus A. Reno Lt. Col. George A. Custer Capt. Fredrick Benteen

Custer (center) ordered Capt. Frederick Benteen (right) to take three companies to scout to the bluffs to the left of the trail. Maj. Marcus Reno (left) was ordered to parallel Custer's five companies down what is now called Reno Creek. A separate company was detailed to accompany the pack train.

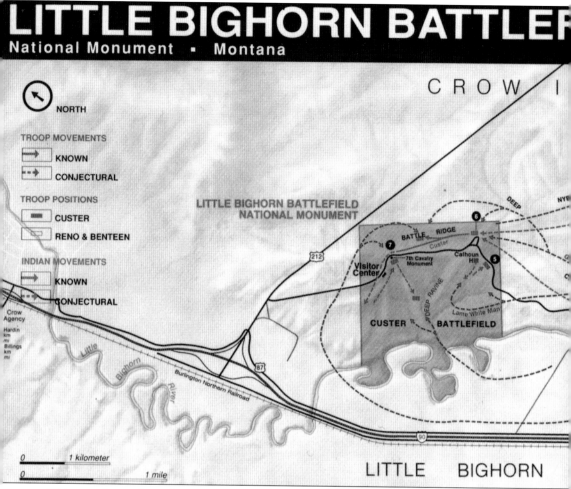

NORTH

TROOP MOVEMENTS

KNOWN

CONJECTURAL

TROOP POSITIONS

CUSTER

RENO & BENTEEN

INDIAN MOVEMENTS

KNOWN

CONJECTURAL

Crow
Agency

Hardin
km
mi
Billings
km
mi

LITTLE BIGHORN BATTLEFIELD
NATIONAL MONUMENT

CROW I

DEEP

NYE

BATTLE RIDGE

Custer

7th Cavalry
Monument

Calhoun
Hill

Visitor
Center

DEEP RAVINE

Lame White Man

CUSTER BATTLEFIELD

Little

Bighorn

River

Burlington Northern Railroad

0 1 kilometer

0 1 mile

LITTLE BIGHORN

This map shows the major movements in the Battle of the Little Bighorn.

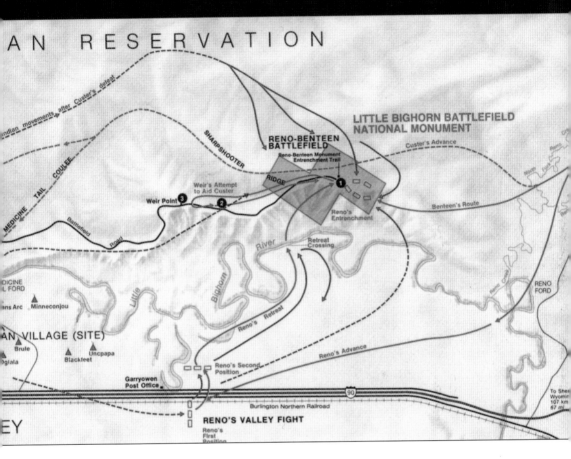

AN RESERVATION

LITTLE BIGHORN BATTLEFIELD
NATIONAL MONUMENT

RENO-BENTEEN
BATTLEFIELD
Reno-Benteen Monument
Entrenchment Trail

Custer's Advance

Indian movements after Custer's defeat

SHARPSHOOTER

MEDICINE TAIL COULEE

RIDGE

Weir's Attempt
to Aid Custer

Weir Point ❸

❷

❶

Reno's
Entrenchment

Benteen's Route

Battlefield

Road

River

Retreat
Crossing

Little

Bighorn

MEDICINE
L FORD

ans Arc Minneconjou

AN VILLAGE (SITE)

Brule Uncpapa
giala Blackfeet

Garryowen
Post Office

Reno's Retreat

Reno's Second
Position

Reno's Advance

RENO
FORD

90

To Shei
Wyomir
107 km
67 mi

Burlington Northern Railroad

EY

RENO'S VALLEY FIGHT

Reno's
First
Position

Photographer Ken Roahen shows the area near the bend of the Little Bighorn River, now called Garryowen, Montana. Near here, Maj. Marcus Reno began the attack on the village with Companies A, G, and M. After the soldiers formed a skirmish line, the warriors began to flank the soldiers' position and they retreated into some nearby trees.

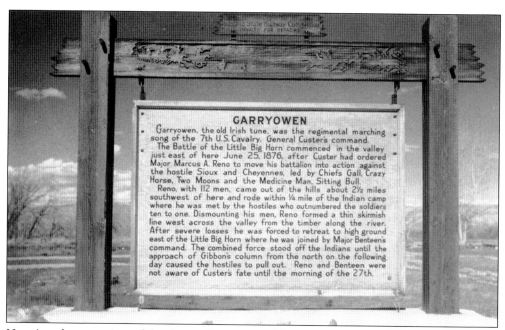

Here is a close-up view of the sign at Garryowen. "Garryowen" is an old Irish drinking song that was adopted by Custer as the regimental tune of his 7th Cavalry. Note the use of the word "hostile" in the text describing the warriors.

This contemporary reenactor shows the uniform and equipment a trooper would have worn in the 7th Cavalry that day. The photograph was taken near the Little Bighorn River.

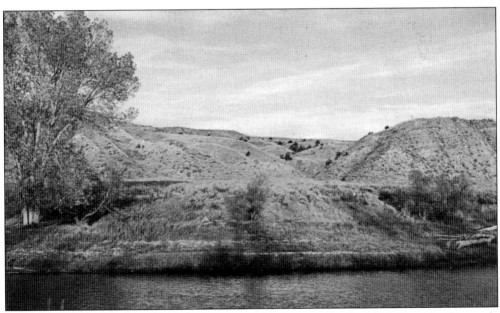

A Ken Roahen image shows the crossing spot at the river used by Reno's troopers as they made a panicked retreat from their wooded position in the valley to the bluffs above, suffering many casualties. The white marker barely visible, right of the cut in the bluffs and just above the riverbank, marks the spot where Lt. Benny Hodgson, Reno's adjutant, was killed. He had become unhorsed but grabbed the stirrup of a trooper and crossed the river, only to be shot by the warriors.

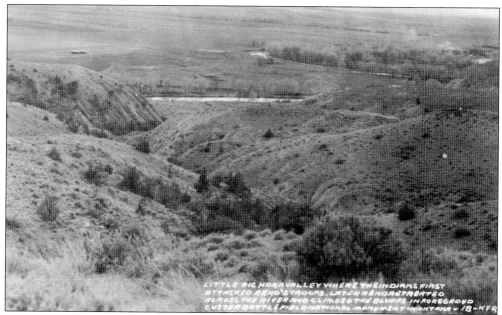

This photograph by Ken Roahen was taken from the bluffs overlooking the Little Bighorn River and looks to the crossing used by Reno's troopers as they fled the warriors.

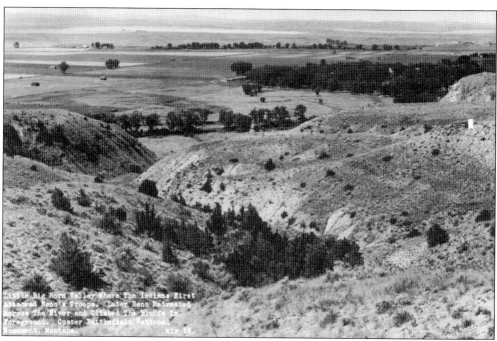

A later photograph by Roahen shows the same spot with more vegetation, especially along the river.

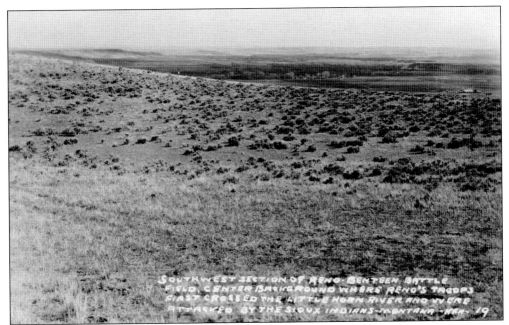

SOUTHWEST SECTION OF RENO-BENTEEN BATTLE FIELD CENTER BACKGROUND WHERE RENO'S TROOPS FIRST CROSSED THE LITTLE HORN RIVER AND WERE ATTACKED BY THE SIOUX INDIANS—MONTANA—KEN. 19

In the late 1940s, Ken Roahen depicts the area where the demoralized men of Reno's command regrouped after their retreat to the bluffs.

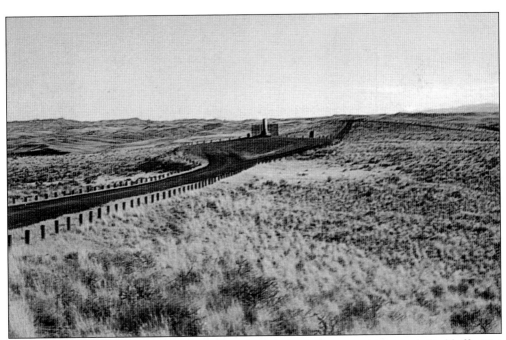

This Ken Roahen photograph from the 1950s reveals the larger area beyond the bluffs. Not long after Reno reached this spot, Capt. Frederick Benteen arrived with his Companies D, H, and K as well as Company B leading the pack train. This would become the area they defended against warrior attack through that day and much of the next. The modern road as shown leads to this spot.

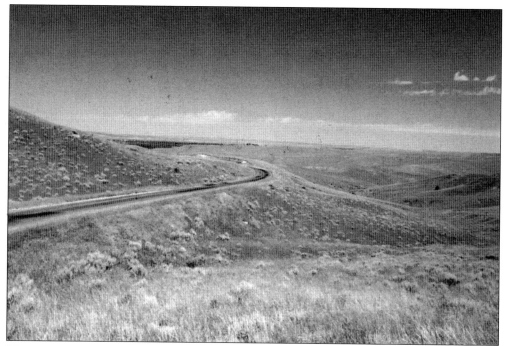

Here is a more contemporary view towards Custer Hill from a series of bluffs now named Weir Point. Capt. Thomas Weir and his Company D left Reno's hilltop position hearing firing farther north. They advanced only to near here, followed eventually by the rest of the command. While they later claimed they could not see much because of the dust and smoke, they may have unknowingly witnessed the end of Custer's fight.

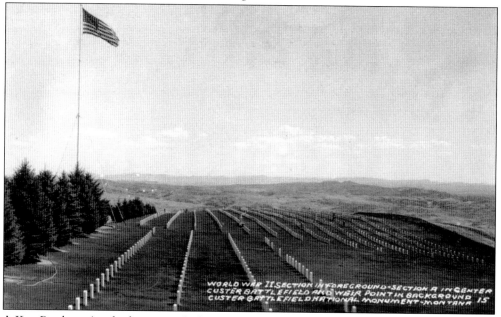

A Ken Roahen view looks over today's national cemetery toward Weir Point, which is located as the notch in the lower bluffs to the right of center. Warrior pressure made the soldiers withdraw to their earlier defensive position.

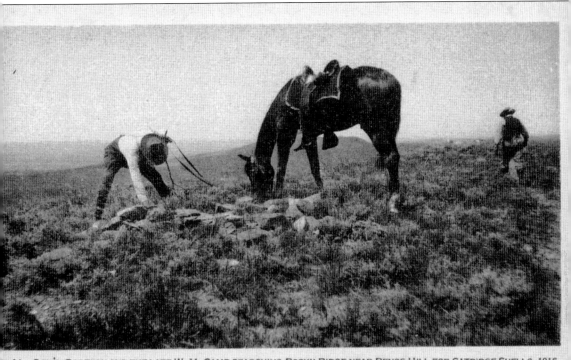

Ð. 14. GEN'L GODFREY AND THE LATE W. M. CAMP SEARCHING ROCKY RIDGE NEAR RENOS HILL FOR CATRIDGE SHELLS, 1916.
© L. A. HUFFMAN, MILES CITY, MONTANA.

This 1916 photograph by L. A. Huffman shows Gen. Edward Godfrey (left), who commanded Company K in Benteen's column, and historian-researcher Walter Camp at the top of Sharpshooter's Ridge. From this position, a Native American marksman, using one of the many firearms the warriors possessed, did much damage to the men in the Reno-Benteen defense perimeter. Finally volley fire from the soldiers silenced this threat. Behind the horse is Weir Point.

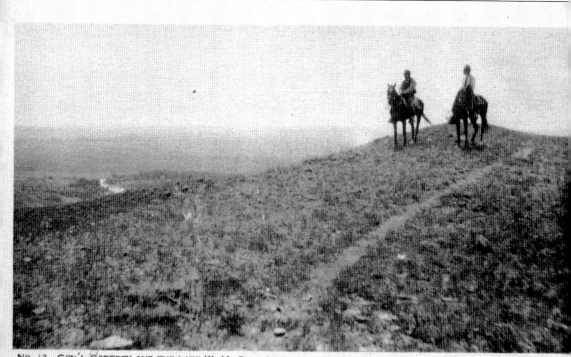

NO. 13. GEN'L GODFREY AND THE LATE W. M. CAMP LOOKING DOWN THE HILL UP WHICH JAMES PYM CARRIED WATER
UPON DEWOLF'S LONE GRAVE, 1916.

© L. A. HUFFMAN, MILES CITY, MONTA

A 1916 Huffman photograph shows General Godfrey and Walter Camp perched on the ridge above the river. Up these ravines, under fire from the warriors, troopers like Pvt. James Pym bravely carried water from the river to relieve the parched men on June 26. Pym and 24 others were awarded the Medal of Honor for such valor in the battle. Also Dr. James DeWolf, one of three doctors with the command, was killed near here going up the wrong ravine in Reno's initial retreat on June 25.

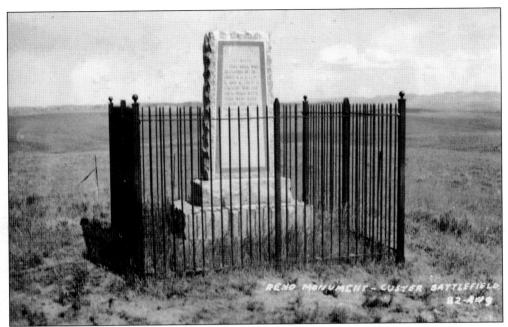

Here is the monument at what is now called the Reno-Benteen Battlefield. In 1926, a wooden cross was placed here to mark the site. For many years, there was controversy about placing any memorial here because of the debate over the conduct of Reno and Benteen, whom many believe failed to relieve Custer.

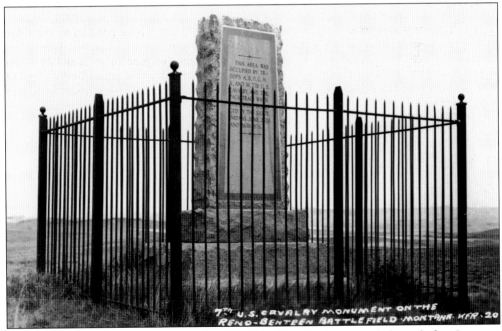

The stone monument, here in a later photograph by Ken Roahen, was dedicated after Congress purchased the 160 acres of land from the Crow tribe in 1929. Because of objections by Custer's widow, Elizabeth, the names of Reno and Benteen were omitted from the text. The 1930 fence around the shaft was removed in 1963.

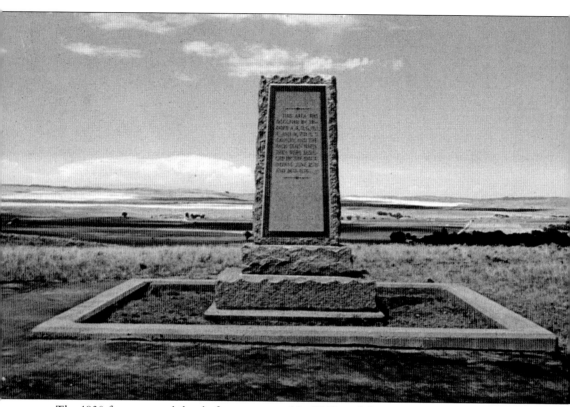

The 1930 fence around the shaft was removed in 1963, and the monument was moved because of road construction and parking expansion. This photograph by Ken Roahen shows the monument at the Reno–Benteen Battlefield in its present location overlooking the valley.

Two

TRAGIC AFTERMATH

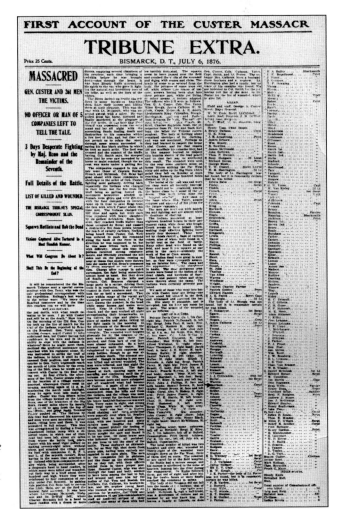

The shocking news of Custer's defeat on June 25, 1876, did not reach the country until just after the nation celebrated its centennial. This is a reproduction of the first newspaper account of the disaster. This special edition was a scoop for *Bismarck Tribune* editor Clement Lounsberry, even though his reporter, Mark Kellogg, died with Custer in the battle.

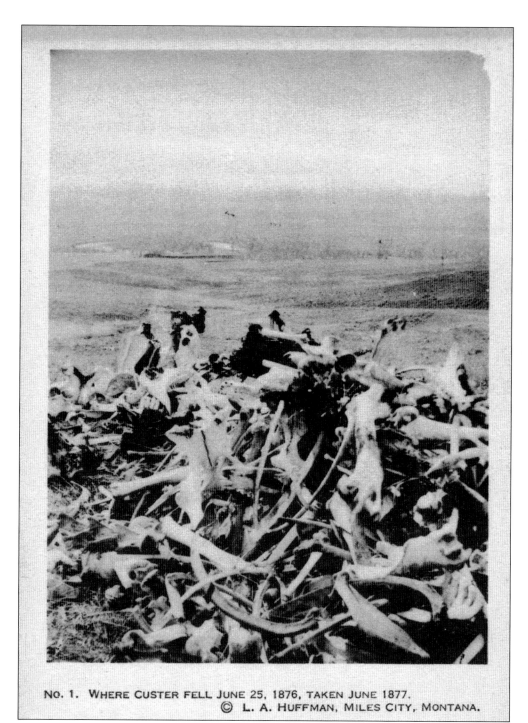

NO. 1. WHERE CUSTER FELL JUNE 25, 1876, TAKEN JUNE 1877.
© L. A. HUFFMAN, MILES CITY, MONTANA.

Stanley Morrow did not take this photograph in June 1877, as stated, but in 1879 when he accompanied Capt. George Sanderson's detail sent to clean up the battlefield. Horse bones piled at the knoll do not obscure the boot on a stake that many scholars now conclude was the actual spot where Custer's body was found on June 27. Custer was buried a little farther down the hill. Captain Sanderson's camp is somewhat visible along the river loop.

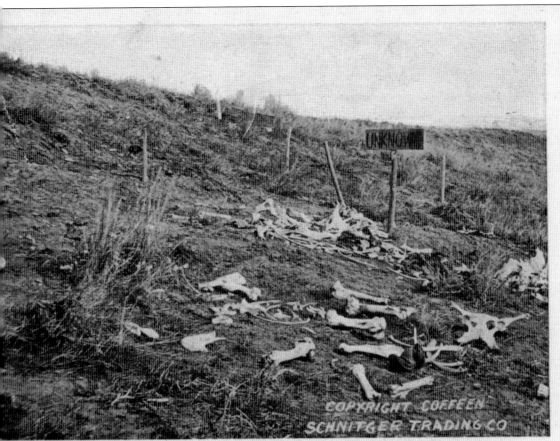

COPYRIGHT COFFEEN
SCHNITGER TRADING CO

Unknown Remains, Custer Battle, June 25, 1876. From Photo Taken One Year Later.

rbert A. Coffeen, Pub., Sheridan, Wyo.

Horse bones and shallow graves are seen in this 1879 photograph by Stanley Morrow on the slope where the last stand was made on Custer Hill. The image is again wrongly identified as being from 1877. It shows the sad condition of the field even after an 1877 burial party had exhumed the bodies of Custer and his officers.

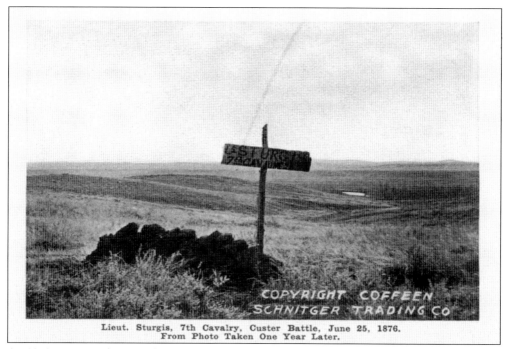

Lieut. Sturgis, 7th Cavalry, Custer Battle, June 25, 1876.
From Photo Taken One Year Later.

An 1879 Morrow photograph shows the spurious grave of Lt. James Sturgis of Company E. Son of the regular colonel of the 7th Cavalry, his body was never identified. When his mother visited the field in 1878, some soldiers put up this grave just below Custer Hill. The fictitious grave eventually disappeared, but today a marble headstone a few yards away from this spot remains.

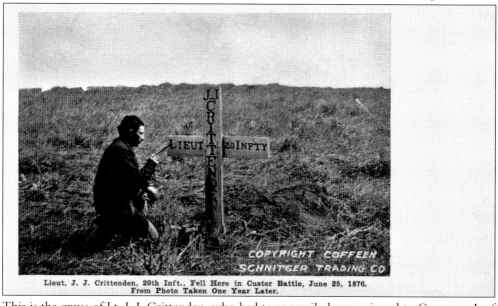

Lieut. J. J. Crittenden, 20th Inft., Fell Here in Custer Battle, June 25, 1876.
From Photo Taken One Year Later.

This is the grave of Lt. J. J. Crittenden, who had temporarily been assigned to Company L of the 7th Cavalry. After the battle, his body had been easily identified because he had a glass eye that had been shattered by an arrow. At the request of his family, Crittenden's body was not removed from the field as were the other officers. The grave remained in this spot until the remains were moved to the national cemetery in 1931.

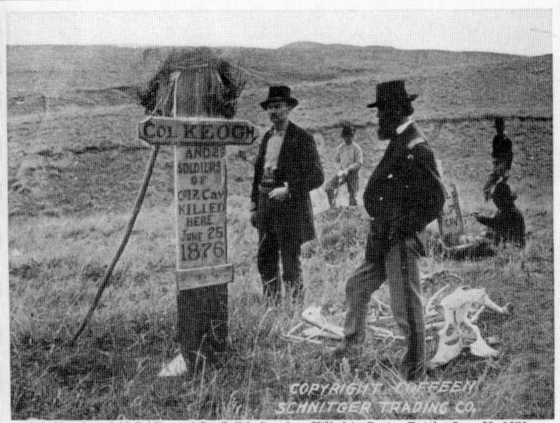

Col. Keogh and 28 Soldiers of Co. I, 7th Cavalry, Killed in Custer Battle, June 25, 1876.
From Photo Taken One Year Later.
Herbert A. Coffeen, Pub., Sheridan, Wyo.

Stanley Morrow had accompanied Capt. George Sanderson of the 11th U.S. Infantry, who led a detail from nearby Fort Custer, to the battlefield in 1879, not 1877, to take this photograph. Sanderson is seen standing not before Capt. Myles Keogh's grave, as marked, but before the makeshift memorial to Keogh and his Company I. Note the soldier behind Sanderson painting a headboard for Cpl. John Wild. This was mistakenly used by some writers to nickname Company I "The Wild I's."

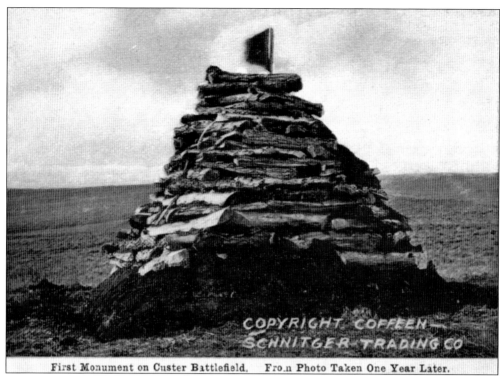

First Monument on Custer Battlefield, Fro.n Photo Taken One Year Later.

Sanderson's efforts to clean up the field are evident in this 1879 Morrow photograph at the top of Custer Hill. The many horse bones were enclosed in a "Cordwood Monument," composed of wood gathered near the river and topped by a flag, which became the first memorial to the 7th Cavalry.

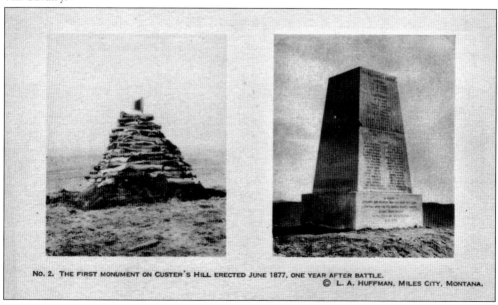

NO. 2. THE FIRST MONUMENT ON CUSTER'S HILL ERECTED JUNE 1877, ONE YEAR AFTER BATTLE.
© L. A. HUFFMAN, MILES CITY, MONTANA.

A comparative photograph documents the 1879 "Cordwood Monument" and the later marble shaft placed in the same spot in 1881. The horse bones were buried in a nearby trench, and today a small marker near the 7th Cavalry Monument marks the spot.

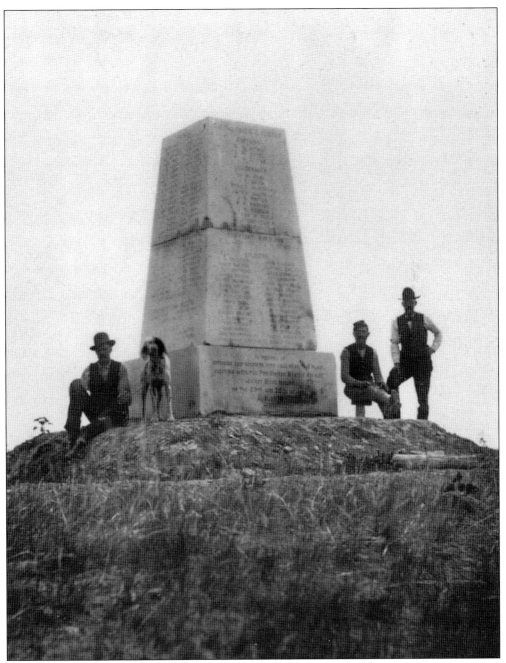

D. F. Barry captured this view of the 7th Cavalry Monument soon after it was erected in 1881 to replace the "Cordwood Monument." The granite shaft, weighing almost 20 tons, was ordered in 1879 and shipped to the battlefield in three sections. The final installation was delayed until 1881. First Lt. Charles Roe directed its erection by the use of a crane constructed from timber cut along the Little Bighorn River. Around it was a trench that would contain the remains of the soldiers whose bodies remained on the field. The four sides were engraved with the names of the officers, soldiers, civilians, and scouts who died in the battle. This mass grave would become a focus of all future commemoration and controversy. (Courtesy of Azuza Publishing.)

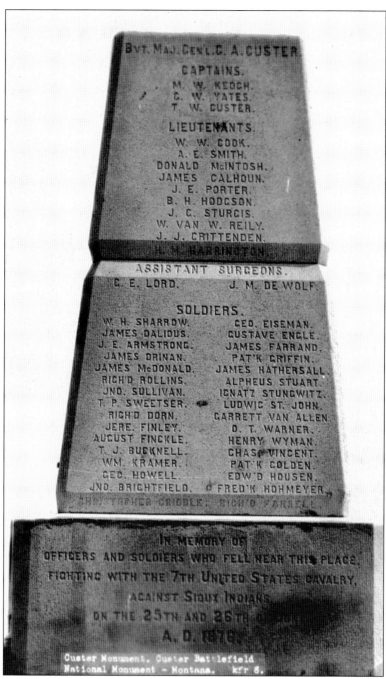

A detailed photograph by Ken Roahen shows the 7th Cavalry mass grave, which unfortunately includes misspellings of even some officers' names, such as Lt. W. W. Cooke, not Cook. In 1877, a party led by Col. Michael Sheridan returned to the battlefield to exhume the bodies of the officers. Custer was reburied at West Point. His brother, Capt. Tom Custer (recipient of two Medals of Honor in the Civil War), was interred at Fort Leavenworth, Kansas, along with Captain George Yates and Lieutenants James Calhoun and Algernon Smith. Capt. Myles Keogh was buried in Auburn, New York.

Another Roahen view details a second side of the 7th Cavalry Memorial.

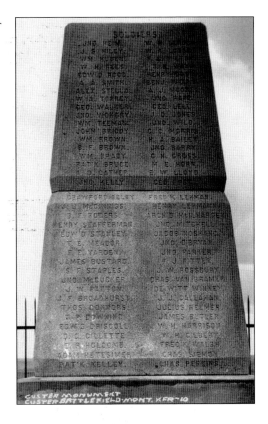

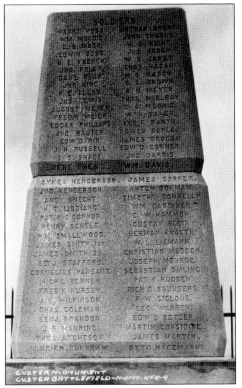

This is another Roahen photograph displaying a third panel of the memorial.

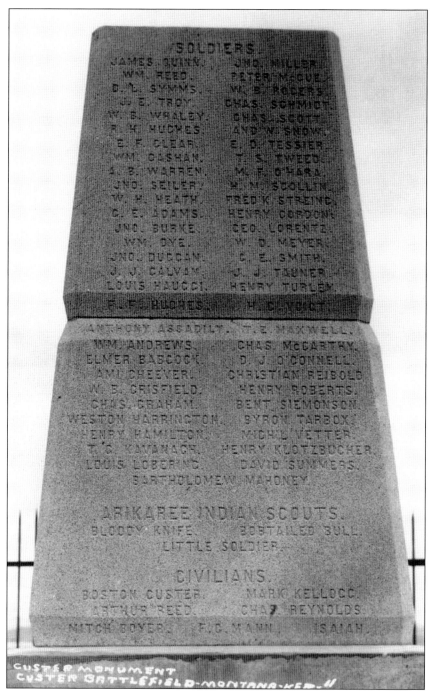

This Roahen photograph shows a fourth side of the 7th Cavalry Memorial. Note the listing of the three Arikaree scouts who died in the battle, especially Bloody Knife, Custer's favorite, who fell in Reno's valley fight. Also among the civilians listed is Boston Custer, younger brother of George and Tom; their nephew Autie Reed (mistakenly listed as Arthur); reporter Mark Kellogg; and Isaiah Dorman (listed only as Isaiah), a black man married to a Sioux who served as an interpreter and died in the valley.

Three

MARKERS TELL A TALE

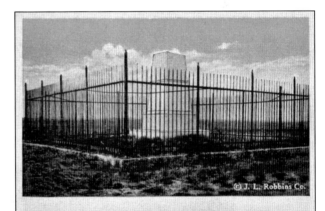

8715 CUSTER'S GRAVE

Yellow haired Chief, they laid you, Custer, here.
You cared not where; nor love, nor grief, nor fear
 Could move you more, in that high bed where blows
 The mountain wind in titan, frenzied throes.

Methinks yon icy stream should cease to sing;
No bird should circle near on carefree wing;
 Those shelt'ring trees and hills should sink away,
 Where slaughter stalked and struck that summer day.

Did Benteen fail? Did Reno coward prove?
YOUR stand, YOUR fight the Indian warriors love,
 And braves in council tell, both crafty foe,
 The Sioux, Cheyennes, and friendly, loyal Crow.

But no Indian yet the fearful ALL has told,
How wave on wave of screaming thousands rolled
 Against that huddled handful massed at bay—
 And not a single white man lived to say.

Such storm blown wastes, with hard blue sky o'erhead!
Such high brown ridge once stained so brightly red!
 And snarling beasts their savage vigil keep,
 Where your two hundred troopers safely sleep.

—AUDREY SOUDER BUCK

The ongoing controversy regarding not only the movements of Custer's five companies in his last battle but also who was to blame for the defeat are well illustrated in this poem. Even though mistitled since Custer was buried at West Point, the mass grave and the markers on the field where the soldiers were found and originally buried offer silent witness to the continuing debate regarding how they fought and died.

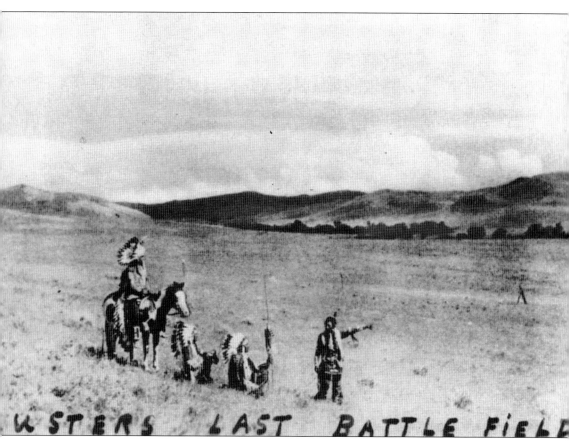

This is a 1926 view by Edwin L. Wisherd as part of a larger series eventually published in *National Geographic* in 1927. Custer sent two companies down a long dry bed called Medicine Tail Coulee, leading to the river crossing. The Cheyenne Cricle, the farthest point of the village on June 25, would have been just across the river here. The village also included Teton Lakota Sioux from the Hunkpapa, Oglala, Minneconjou, Blackfeet, Sans Arc, Brule, and Two Kettle bands as well as Santee and Dakota Sioux and five Arapahos. Many warriors would cross here to attack Custer.

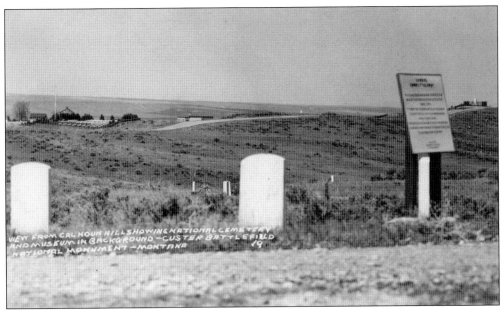

Ken Roahen shows the location where Lt. James Calhoun commanded Company L. Evidence suggests that he separated his men into two platoons, forming skirmish lines. They attempted to hold this spot until being overrun by warriors. Note the earlier version of the interpretive marker.

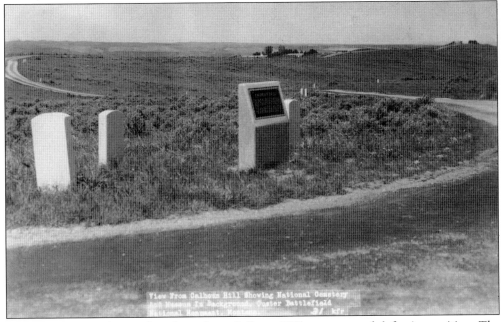

A later photograph by Roahen shows how Calhoun Hill was a natural defensive position. The interpretive markers with aluminum plates on concrete bases, as pictured here, replaced the former ones. They would last for 45 years until today, when new porcelain enamel panels help visitors follow the battle.

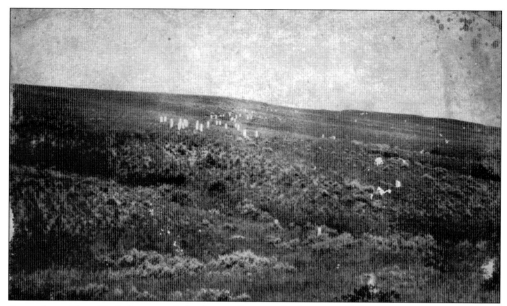

An early unidentified photograph looks north towards Custer Hill from the Keogh position.

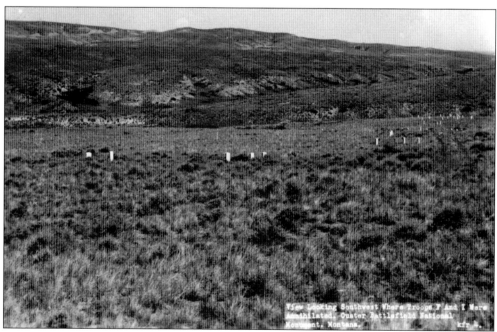

Keogh's position from the ridge is visible in this Ken Roahen photograph. Some evidence suggests that Keogh held his men in reserve until overwhelmed by warriors under Crazy Horse, who separated them from Custer Hill. The scattered markers may be those attempting to escape to Custer Hill.

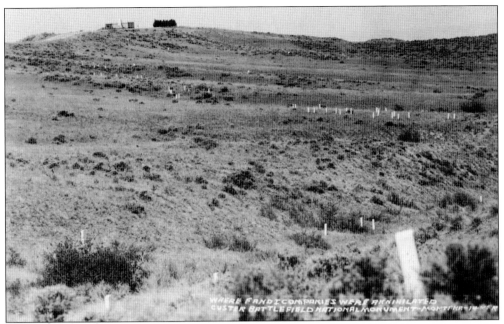

These views by Ken Roahen from the 1940s offer a different perspective of Keogh's position looking northwest toward Custer Hill. The trees on the backside of Custer Hill were used to hide the view of a large water tank that is no longer present.

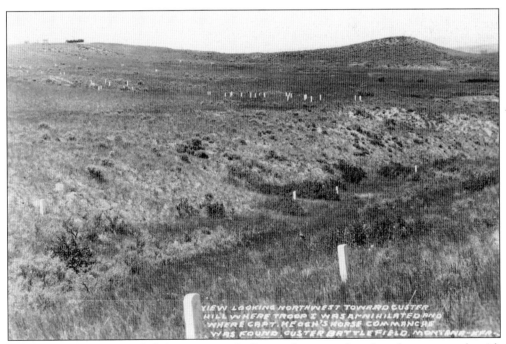

Captain Keogh's wounded horse, named Comanche, was found and transported with the wounded men back to Fort Lincoln. He became a mascot and honored symbol of the 7th Cavalry.

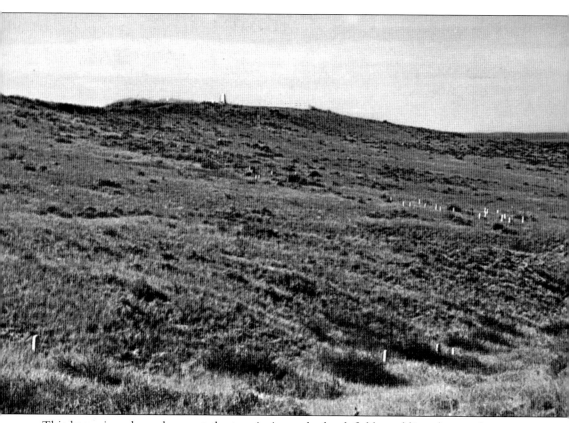

This later view shows how cut the terrain is on the battlefield, enabling the warriors to get closer to the soldiers.

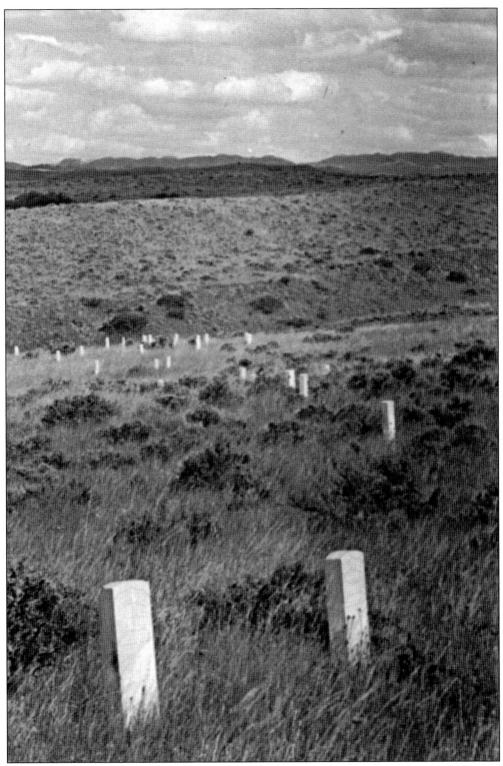

The Keogh position is featured here.

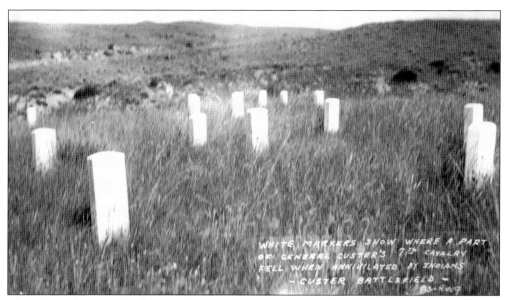

This closer photograph of the markers in the Keogh area may reflect the breakdown of troop formation as they fought off warriors in a number of directions.

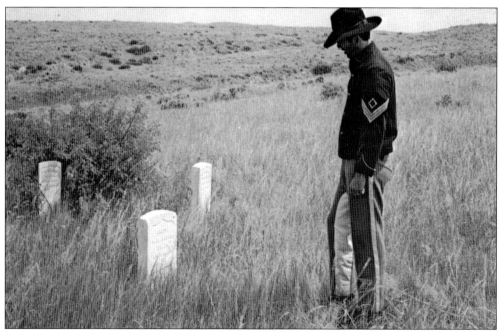

A soldier reenactor stands near the marker where Keogh's body was supposedly found. This marker was relocated to the correct position in 1982.

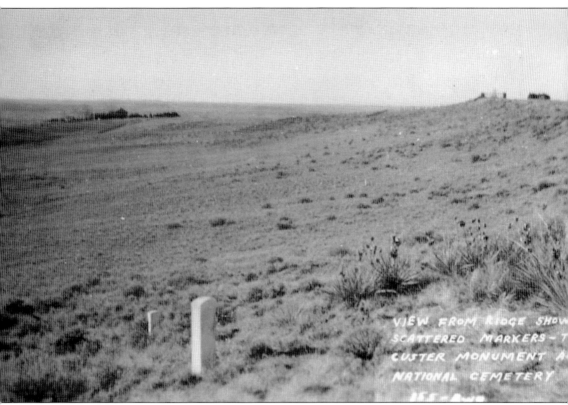

VIEW FROM RIDGE SHOW
SCATTERED MARKERS - T
CUSTER MONUMENT A
NATIONAL CEMETERY

This photograph taken from the ridge shows two markers. Note the monument on the upper right and the Stone House and cemetery on the left. Recent archaeological work at the battlefield suggests that many dual markers like this were placed incorrectly so that two mounds represented but one grave.

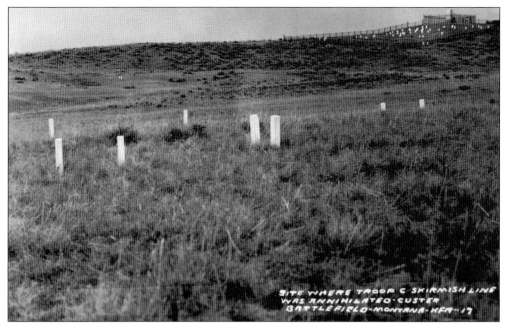

Ken Roahen depicts some of the paired markers that, despite the description, may not have been the result of a skirmish line.

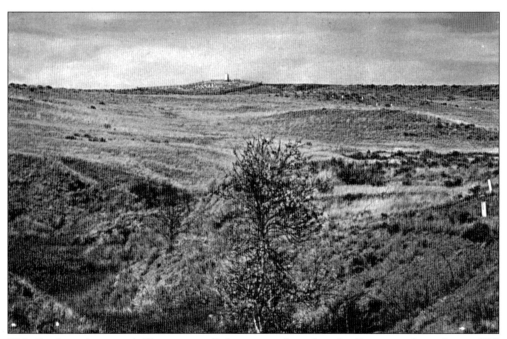

This Roahen photograph illustrates well the scattered markers leading away from Custer Hill down toward the river along what is called the South Skirmish Line. There remains a debate among students of the battle about what these markers mean. Native American testimony suggests that soldiers of Company E (on gray horses), not Company C as traditionally believed, moved to this basin but "suicide" warriors stampeded the horses, causing the men to flee to Custer Hill.

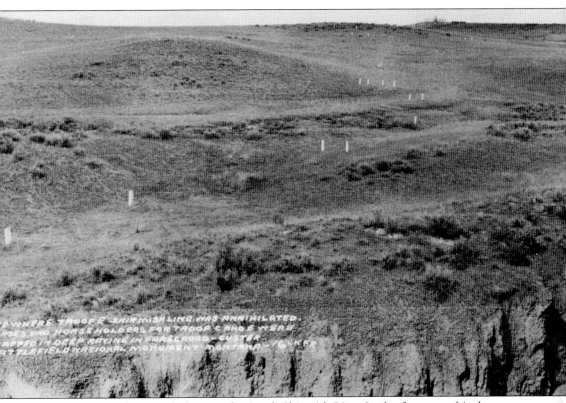

A 1940s Roahen photograph features the South Skirmish Line. In the foreground is the steep wall of Deep Ravine. Many accounts state that about 28 soldiers either were sent or driven there and trapped. The markers here may actually be for the bodies of men in the ravine who have never been recovered. Archaeological evidence has been inconclusive on this.

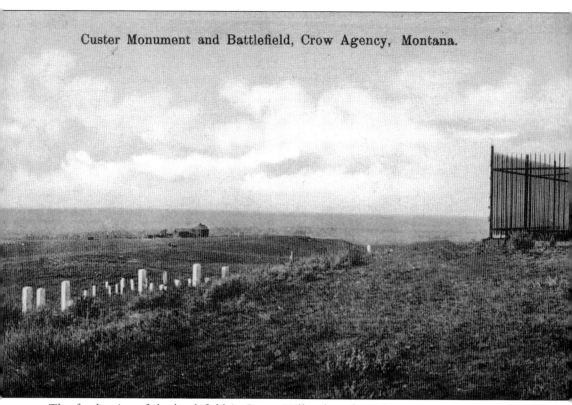

Custer Monument and Battlefield, Crow Agency, Montana.

The focal point of the battlefield is Custer Hill, where legend states Custer made his "last stand." This panoramic scene shows the contour of the ridge. The date of the view must be after

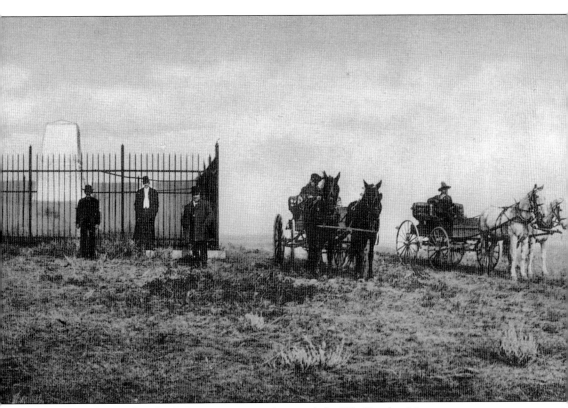

1883, when the 10-foot-high fence was erected around the 7th Cavalry Monument to protect it. In the distance is the Stone House, built in 1894.

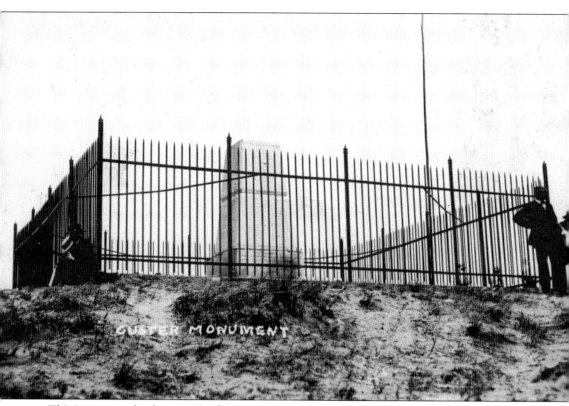

This is a very early photograph of the monument, showing the steepness of the hill before it was leveled off by road construction.

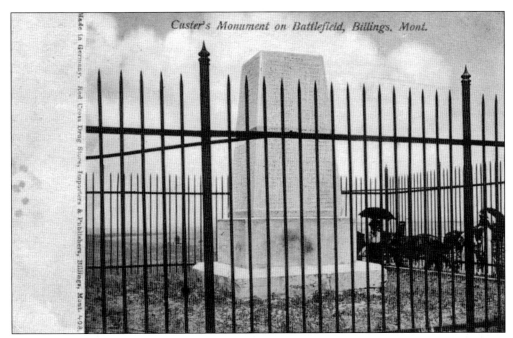

Another early photograph of the monument appears here. According to modern historians, Custer's body was found in the foreground of this picture around other dead soldiers and horses. He was buried, though, on the slope below, which has been misnamed the place where Custer fell.

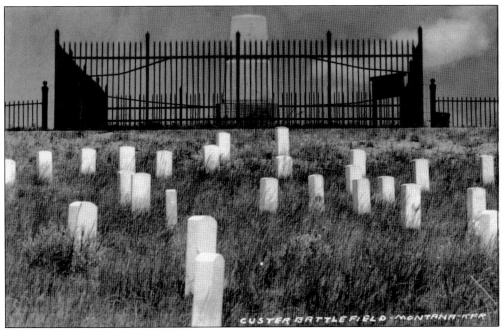

In this later Ken Roahen image, the place where Custer's body was found would have been to the right of the monument at the crest of this ridge.

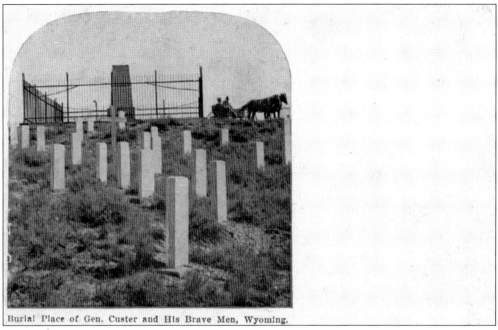

Burial Place of Gen. Custer and His Brave Men, Wyoming.

Three days after the battle, details from Major Reno's surviving command arrived to bury their dead comrades. With few shovels and little time, the men interred most of the bodies in shallow graves, with a stake driven into the ground for identification. After numerous attempts to clean up the field of bones and scattered debris, Capt. Owen Sweet was sent to install these marble markers. Note that the caption reads Wyoming instead of Montana.

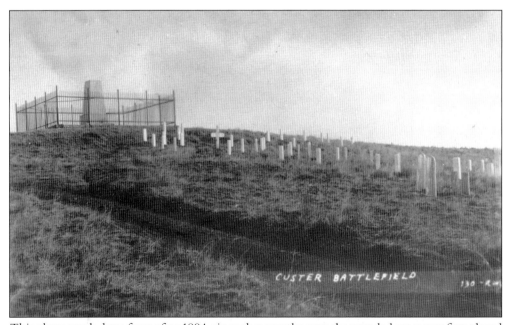

CUSTER BATTLEFIELD

This photograph dates from after 1894, since that was the year the wooded cross was first placed over Custer's grave site. At the right center are two wooden headboards for Custer's brother Boston and nephew Autie Reed. As civilians, they would not receive marble markers.

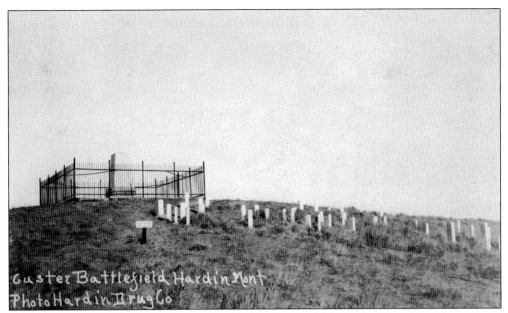

Custer Battlefield Hardin Mont
Photo Hardin Drug Co

When Captain Sweet arrived, he had marble headstones for both the Custer and Reno dead. Unfortunately, he placed 246 markers primarily on the Custer field, which should only have had 210, complicating further study of where the soldiers were buried. This undated photograph shows many more markers than should be on Custer Hill.

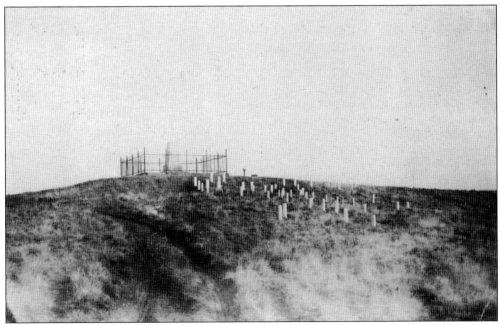

This is another undated photograph of Custer Hill.

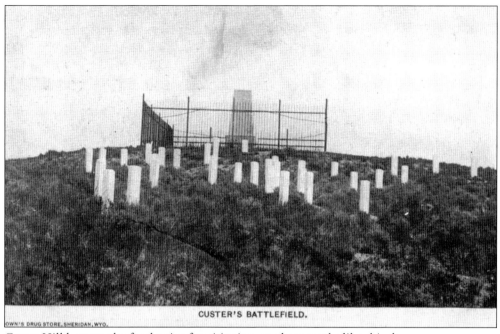

CUSTER'S BATTLEFIELD.

OWN'S DRUG STORE, SHERIDAN, WYO.

Custer Hill became the focal point for visitation, as photographs like this show.

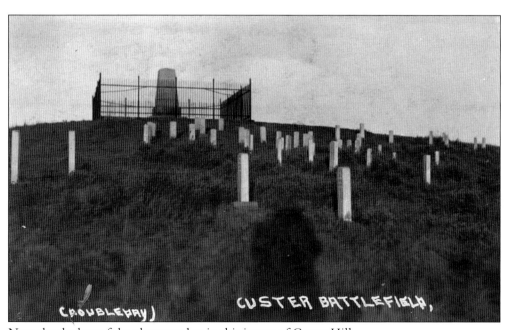

(CROUBLEURY) CUSTER BATTLEFIELD,

Note the shadow of the photographer in this image of Custer Hill.

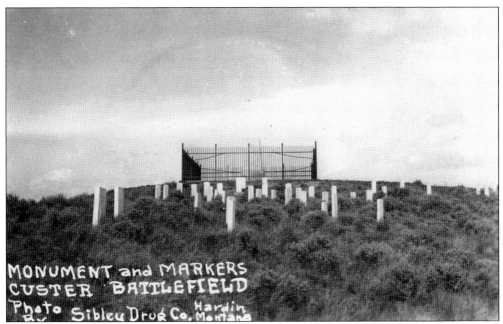

This postcard was distributed by a drugstore in Hardin, Montana, a town about 12 miles from the battlefield.

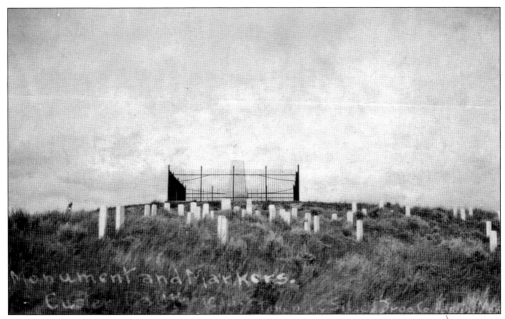

Photographs like these became popular postcards for visitors to the area.

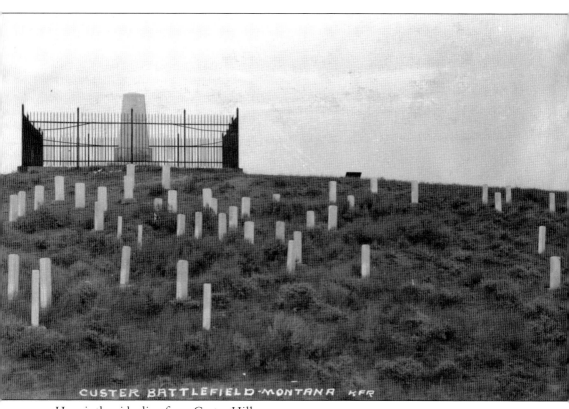

CUSTER BATTLEFIELD MONTANA KFR

Here is the ridgeline from Custer Hill.

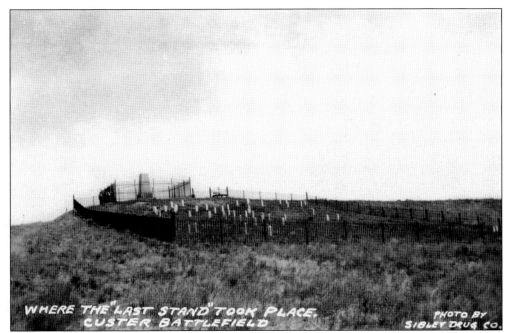

This photograph dates after 1930, when a 4-foot fence was erected around the markers on Custer Hill.

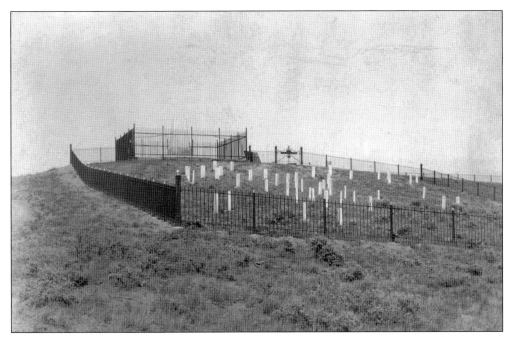

Although the 10-foot fence around the monument was removed in 1963, the group-erected 4-foot fence surrounding the hillside marker to protect them from vandalism still stands today.

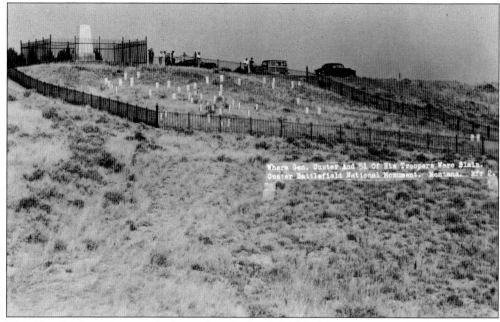

This Ken Roahen photograph shows that the battlefield had become a popular destination by the 1950s.

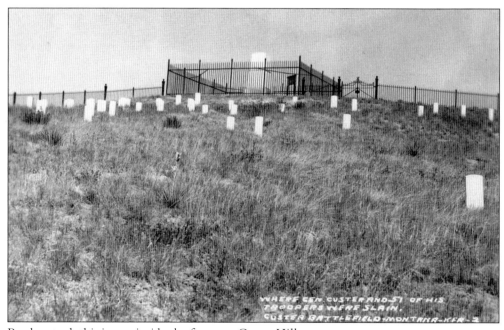

Roahen took this image inside the fence on Custer Hill.

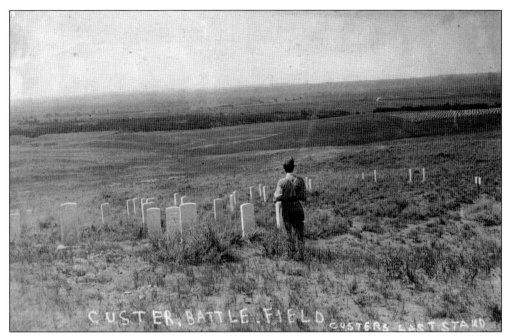

An undated photograph provides a view from Custer Hill towards Deep Ravine. Note the national cemetery to the right.

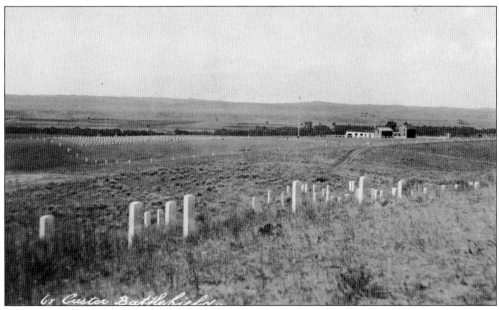

The slope of Custer Hill and the dirt road connecting it to the national cemetery and the Stone House are clearly seen here.

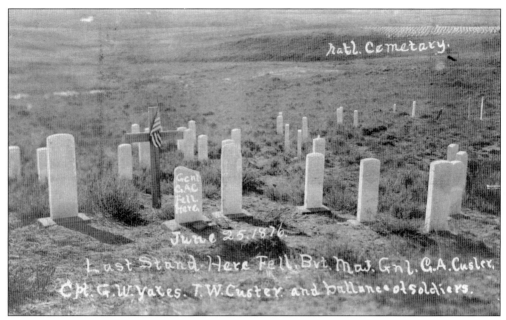

Souvenir hunters regularly would chip away at the markers, especially Custer's. Such vandalism would lead to the appointment of a permanent superintendent, Andrew Glover, to protect the site in 1893.

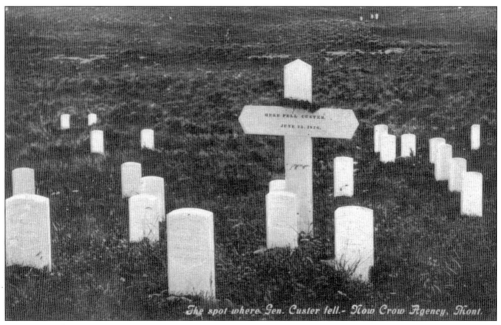

This view from the late 1890s shows the cross marking "where Custer fell" actually was where he was buried. A number of wooden crosses were used over the years to highlight the spot.

Fred Miller photographed the wood cross at Custer's burial site in 1898. Note the deterioration of the wood, either from nature or vandals.

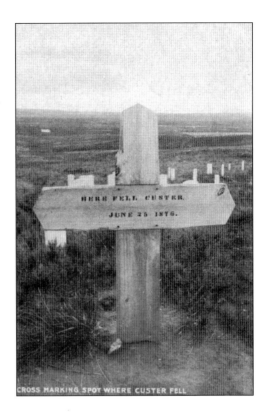

CROSS MARKING SPOT WHERE CUSTER FELL

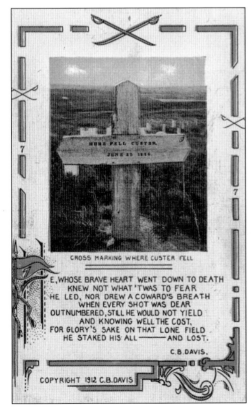

CROSS MARKING WHERE CUSTER FELL

E, WHOSE BRAVE HEART WENT DOWN TO DEATH
KNEW NOT WHAT 'TWAS TO FEAR
HE LED, NOR DREW A COWARD'S BREATH
WHEN EVERY SHOT WAS DEAR
OUTNUMBERED, STILL HE WOULD NOT YIELD
AND KNOWING WELL THE COST,
FOR GLORY'S SAKE ON THAT LONE FIELD
HE STAKED HIS ALL ———— AND LOST.

C.B. DAVIS.

COPYRIGHT 1912 C.B.DAVIS

This 1912 variation of the 1898 photograph captures well the prevailing sentiment of the time regarding the heroic sacrifice of Custer and his men.

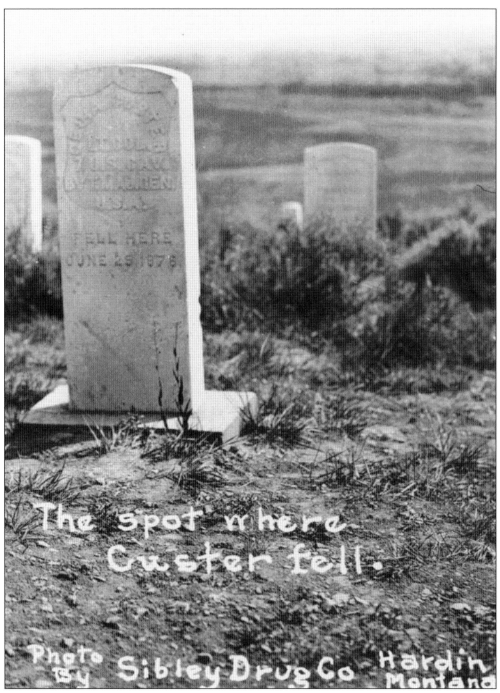

The spot where Custer fell.

Photo By Sibley Drug Co Hardin Montana

The first marble marker for Custer was in place by 1912. The marker reads, "G. A. Custer / Lt. Col. Bvt. Maj. Gen. / U.S.A. / Fell Here / June 25, 1876." Brevet ranks were wartime promotions for gallant service. Custer was promoted to brevet brigadier general and later major general during the Civil War. After the war, he reverted back to his regular army rank of captain but was soon promoted to lieutenant colonel of the 7th Cavalry in 1866, the rank he maintained until his death. Even then, he was usually addressed as "General" Custer.

Four

BURIALS AND BEYOND

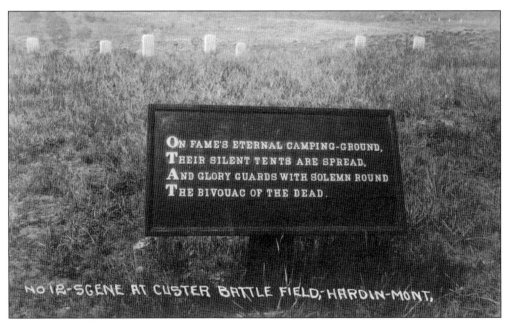

ON FAME'S ETERNAL CAMPING-GROUND,
THEIR SILENT TENTS ARE SPREAD,
AND GLORY GUARDS WITH SOLEMN ROUND
THE BIVOUAC OF THE DEAD.

NO 18-SCENE AT CUSTER BATTLE FIELD, HARDIN-MONT,

This plaque, originally on the battlefield proper, is now located in what is today the Custer National Cemetery. The last verse of an 1847 poem by Theodore O'Hara entitled "The Bivouac of the Dead" reflects well that Little Bighorn is not only a place of conflict but the resting place for many who fought and often died for their way of life.

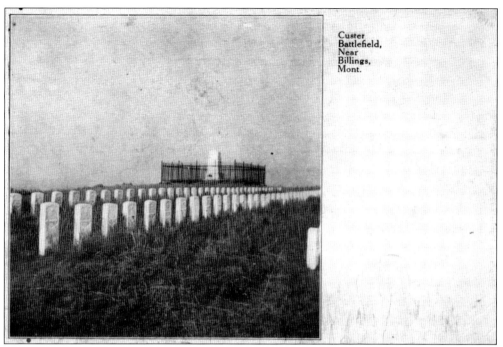

Custer
Battlefield,
Near
Billings,
Mont.

On December 21, 1866, a party of woodcutters and teamsters left Fort Phil Kearny but were attacked by a party of Sioux. Col. Henry Carrington sent Capt. William Fetterman along with Capt. Frederick Brown to rescue the party. Fetterman and his 81 men rode into an ambush and were all killed by a force of 2,000 warriors. Originally buried at Fort Kearny's cemetery, the bodies were disinterred and buried at Custer Battlefield in 1888.

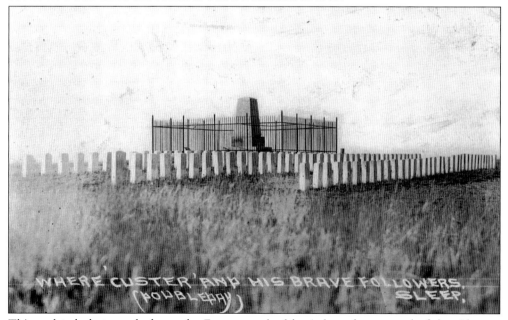

This undated photograph shows the Fetterman dead buried on the east end of the ridge on Custer Hill. Unfortunately, this would leave the false impression that these were the dead from Custer's command.

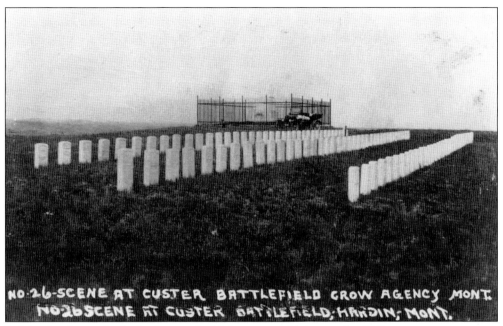

NO·26-SCENE AT CUSTER BATTLEFIELD CROW AGENCY MONT.
NO26 SCENE AT CUSTER BATTLEFIELD, HARDIN, MONT.

Judging by the car in the background, this image would date to the 1910s.

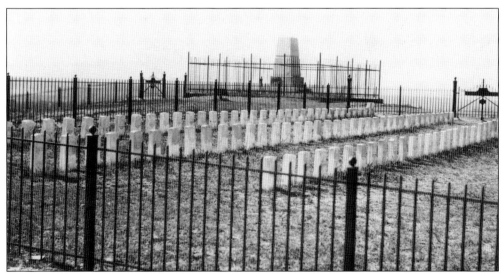

This very rare photograph shows that the Fetterman dead remained on the ridge on Custer Hill until 1930, when the 4-foot fence was installed around the hillside markers. These bodies were disinterred and moved to the national cemetery below in 1934.

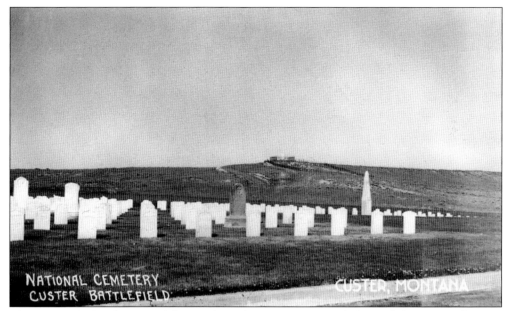

The Fort C. F. Smith Memorial is on the right. Fort C. F. Smith, located about 40 miles west of the battlefield, was built in 1866 as one of the forts protecting the Bozeman Trail, under constant attack by Native Americans. This memorial honors those who died at the post and especially the Hayfield Fight on August 1, 1867. The memorial was brought when the dead from the post were reinterred here in 1892.

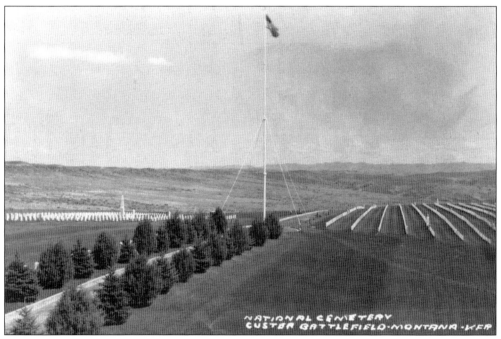

This late-1940s view by Ken Roahen shows the expansion of the cemetery. The Fort C. F. Smith Memorial is to the left of the flagpole.

This early view of the national cemetery clearly shows the absence of trees and shrubs.

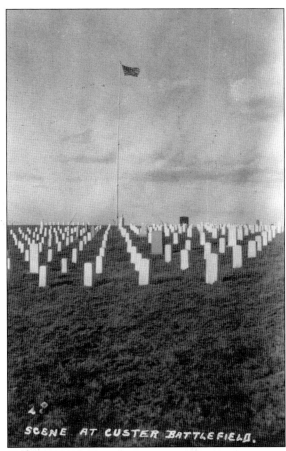

SCENE AT CUSTER BATTLEFIELD.

The absence of trees and shrubs was explained as a result of a lack of water.

816-SCENE AT, CUSTER BATTLEFIELD.

This early view of the national cemetery displays its varied markers. The notion of uniform markers in national military cemeteries has not always been the practice.

The remains from many of the closed forts from the Indian Wars period were reinterred here in the national cemetery.

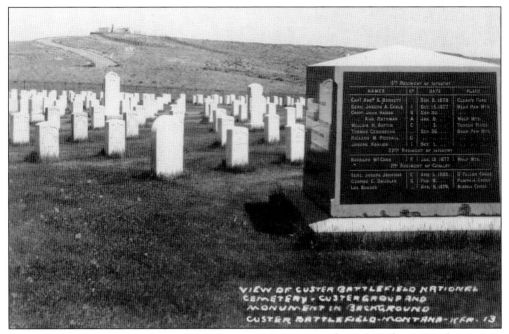

The graves of the dead from Fort Keogh in Montana were reburied in the national cemetery in 1924.

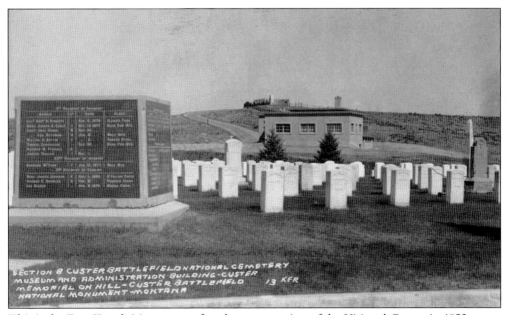

This is the Fort Keogh Monument after the construction of the Visitors' Center in 1952.

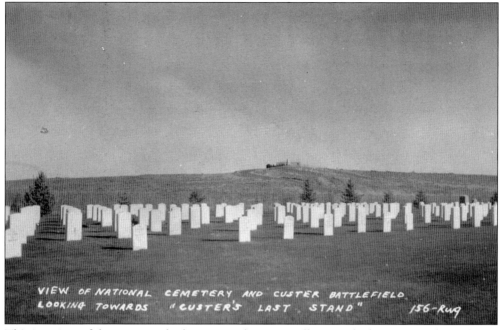

This is a view of the cemetery looking toward Custer Hill. Note the beginning of trees being planted as well as the fence.

The growth of more trees and shrubs in the cemetery has become a permanent feature.

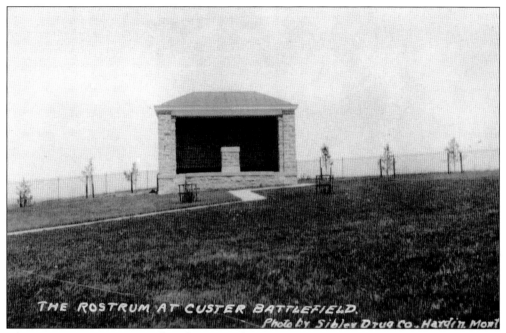

THE ROSTRUM AT CUSTER BATTLEFIELD.
Photo by Sibley Drug Co. Hardin Mont

This rostrum was constructed in the national cemetery in 1934. It was used for ceremonies at the battlefield for many years. Note the fence and the newly planted trees.

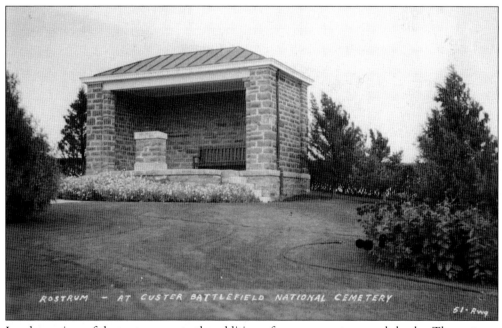

ROSTRUM — AT CUSTER BATTLEFIELD NATIONAL CEMETERY

51-Rwg

In a later view of the rostrum, note the addition of many more trees and shrubs. The rostrum was eventually demolished in 1965.

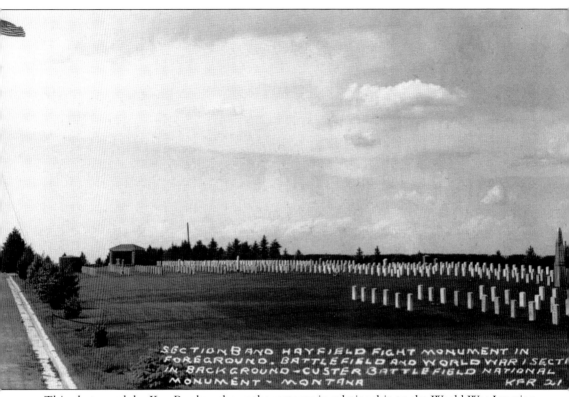

SECTION B AND HAYFIELD FIGHT MONUMENT IN FOREGROUND. BATTLEFIELD AND WORLD WAR I SECTI IN BACKGROUND—CUSTER BATTLEFIELD NATIONAL MONUMENT—MONTANA KFR 21

This photograph by Ken Roahen shows the rostrum in relationship to the World War I section of the cemetery. Many veterans from World War I and II, Korea, Vietnam, and others who served, as well as dependents, are buried are buried in the national cemetery. Note the Fort C. F. Smith (Hayfield Fight) Monument on the far right.

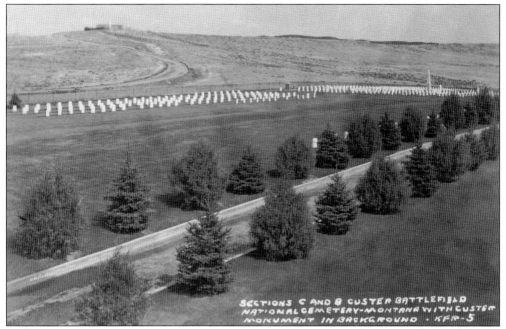

Before the construction of the new Visitors' Center, sections B and C in the national cemetery are depicted here in a 1952 Ken Roahen image.

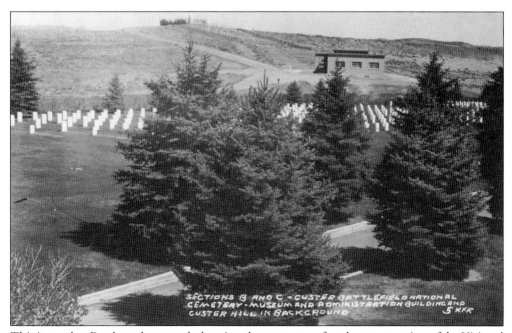

This is another Roahen photograph showing the same area after the construction of the Visitors' Center in 1952. Note how many more trees there are.

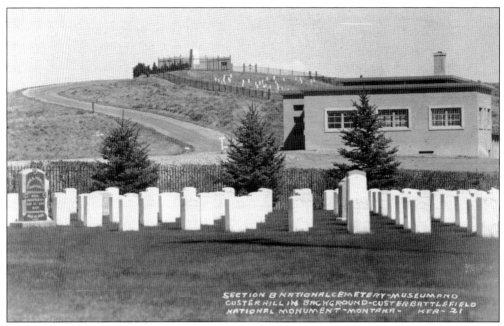

This view of the Visitors' Center from the early 1950s is looking up to Custer Hill. Note the fence separating the building from the cemetery. This fence no longer exists.

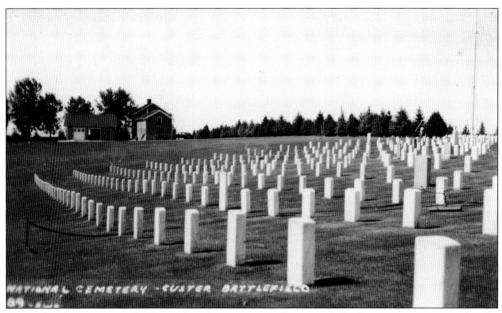

An undated photograph in the national cemetery looks toward the Stone House. Note that by this time many of the outbuildings had been demolished to make room for more burials. The open area pictured here is completely filled in with markers today.

CUSTER NATIONAL CEMETERY

Today Custer National Cemetery is closed to new burials but continues to be an honored place of rest for those who fought and often died in the service of their country. Among these are the remains of soldier casualties from the Battle of Little Bighorn whose bones have been uncovered in subsequent archeological surveys of the battlefield.

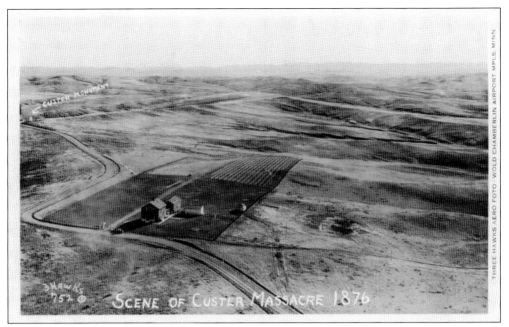

This rare aerial photograph of the battlefield was probably taken sometime between 1931 and 1934. It looks toward the south with the cemetery and Stone House in the foreground and Custer Hill on the far left.

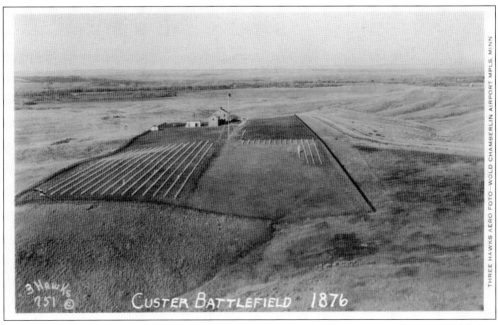

A second aerial view faces north this time. Note the lack of trees. Custer Hill is not visible but would be off to the right.

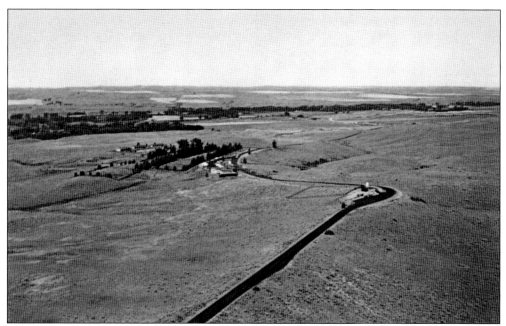

This is a later aerial view showing Custer Hill at the right center and the modern road along the ridge.

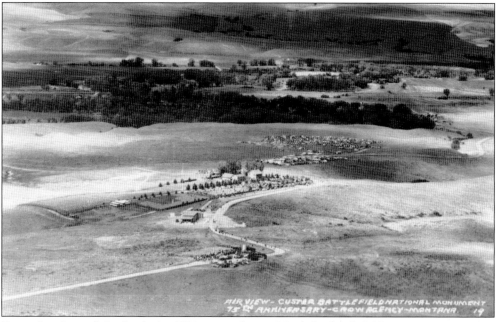

From the time of the battle in 1876, many have visited the battlefield. Some were curious visitors, but also both soldier and Native American veterans returned. Over the years, the battle was commemorated often with reunions of participants. This aerial view is of the 75th anniversary of the battle, June 25, 1951. Note that the Visitors' Center is still in the process of being completed.

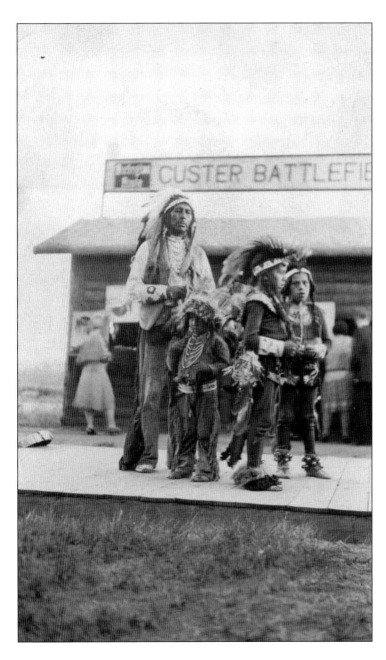

The Burlington Railroad ran along the battlefield, and during the summer trains would stop for 15 minutes at a special sightseeing platform to view the battleground. Here is a Native American family at the Burlington stop.

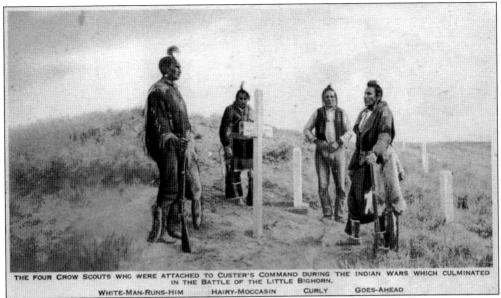

THE FOUR CROW SCOUTS WHO WERE ATTACHED TO CUSTER'S COMMAND DURING THE INDIAN WARS WHICH CULMINATED IN THE BATTLE OF THE LITTLE BIGHORN.

WHITE-MAN-RUNS-HIM HAIRY-MOCCASIN CURLY GOES-AHEAD

The Burlington Railroad published a series of postcard views promoting their trips through Montana. This photograph is of the four Crow Indian scouts who served under Custer during the Little Bighorn campaign. Here they are surrounding the cross where Custer was buried. Curly, just to the right of the cross, reputedly stayed with Custer and escaped to report the news to the unbelieving soldiers on the steamer *Far West* of Custer's disaster.

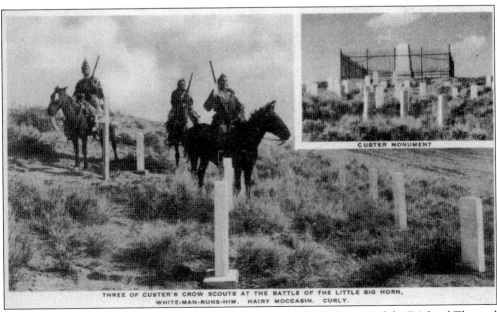

CUSTER MONUMENT

THREE OF CUSTER'S CROW SCOUTS AT THE BATTLE OF THE LITTLE BIG HORN, WHITE-MAN-RUNS-HIM. HAIRY MOCCASIN. CURLY.

A Burlington Railroad postcard from the 1920s reprints a 1908 photograph by Richard Throssel of the three Crow scouts.

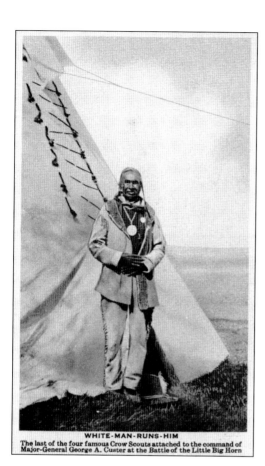

Another Burlington Railroad postcard shows the Crow scout White Man Runs Him in his later years.

WHITE-MAN-RUNS-HIM
The last of the four famous Crow Scouts attached to the command of Major-General George A. Custer at the Battle of the Little Big Horn

MAX BIG-MAN, FULL-BLOOD CROW INDIAN, WHOSE HOME IS ON THE CROW RESERVATION NEAR THE CUSTER BATTLEFIELD. HIS NAME IN THE CROW LANGUAGE IS IHAH-TOH-HEH-ED-DEHSH, WHICH MEANS "GRABS-THE-ENEMY'S GUN". HIS TWO SONS ARE PROFICIENT DANCERS.

The Little Bighorn battlefield is located on the Crow Indian Reservation. This Burlington Railroad postcard illustrates this well.

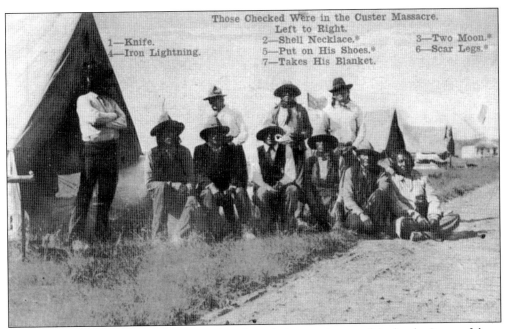

Native American veterans often gathered to share their experiences of the battle. Some of those in this undated photograph were participants of the battle.

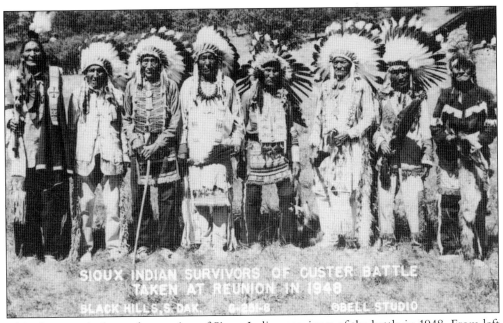

This photograph shows the reunion of Sioux Indian survivors of the battle in 1948. From left to right are Little Warrior, Pemmican, Little Soldier, Dewey Beard, John Sitting Bull, High Eagle, Iron Hawk, and Comes Again.

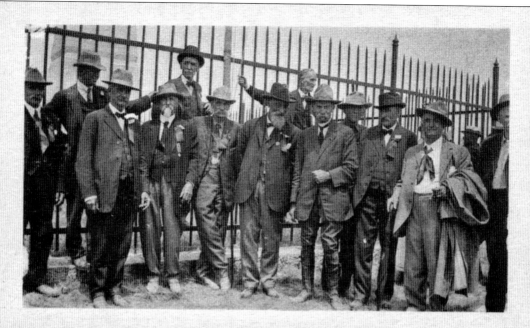

No. 11. GEN'L GODFREY AND A BUNCH OF OLD TIMERS AT THE MONUMENT 1916.

© L. A. HUFFMAN, MILES CITY, MONTANA

L. A. Huffman took this photograph of Gen. Edward Godfrey (fifth from right, to the right of the man with the long beard), veteran of the battle, with a "bunch of old timers" in front of the 7th Cavalry Monument during the 40th anniversary of the battle in 1916. This event brought almost 4,000 visitors, including Native Americans, to the battlefield. General Godfrey led a soldier contingent that exchanged gestures of friendship with Two Moon, who led a party of warriors. He also read a speech for Elizabeth Custer, and there were volleys fired over the mass grave.

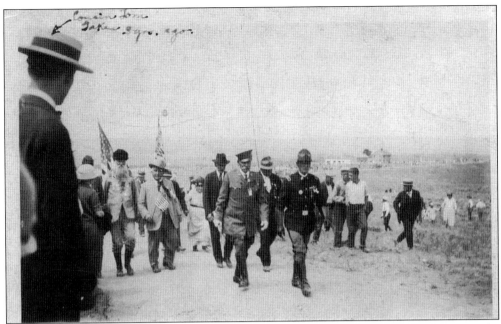

The 50th anniversary of the battle in 1926 brought estimates of over 35,000 people to the battlefield, including over 13,000 automobiles. This photograph depicts dignitaries gathering for the festivities. Shown in front from left to right (starting from the flag at left) are Capt. O. C. Applegate, Indian Wars veteran; Tony Barron, National Veterans of the Indian Wars; Gen. Edward Godfrey, veteran of the battle; A. B. Ostrander, veteran writer and special correspondent of the *Winners of the West* magazine; Russell White Bear, Crow tribal leader and interpreter; and Col. John Brandt, commander in chief, National Veterans of the Indian Wars. Note that the man in the straw hat on the far left, facing away from the camera, is Dr. Thomas Marquis, a longtime student and writer on the Custer battle.

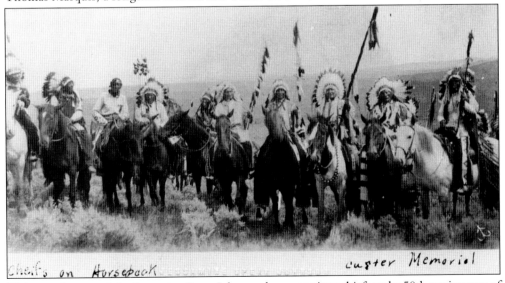

This rare photograph by Jessamine Spear Johnson shows survivor chiefs at the 50th anniversary of the battle on June 26, 1926. Johnson, along with her sister Elsa Spear Byron, took many images of these anniversary events. (Reproduced courtesy of Azuza Publishing and Marilyn Bilyeu.)

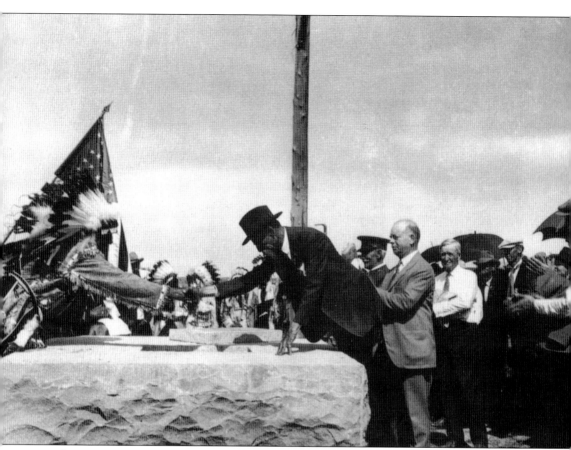

Elsa Spear Byron captured this image from the 50th anniversary. It shows General Godfrey and Sioux Chief White Bull over the grave of an unknown soldier from Reno's retreat discovered near the Garryowen loop. Pictured is the gesture of friendship between two old foes after "burying the hatchet."

Five

HOUSING HISTORY

This is a view from a distance of the old gate into Custer Battlefield.

Entrance to Custer Battlefield National Cemetery, Montana.

The entrance to the battlefield is shown here by an unknown photographer and was published by Robbins-Tillquist Company of Spokane, Washington. The sign on the right states, "You are invited to apply at office for information and to register." The Stone House on the left served as headquarters for the battlefield and home for the superintendent.

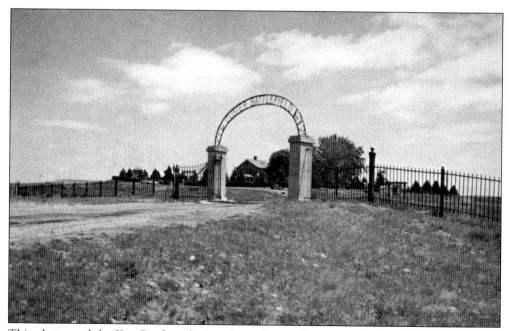

This photograph by Ken Roahen depicts the arch over the gate of the battlefield, constructed at an unknown date. It was also removed at an unknown date when the new entrance road was constructed in 1957. Note the rostrum on the very left of the picture.

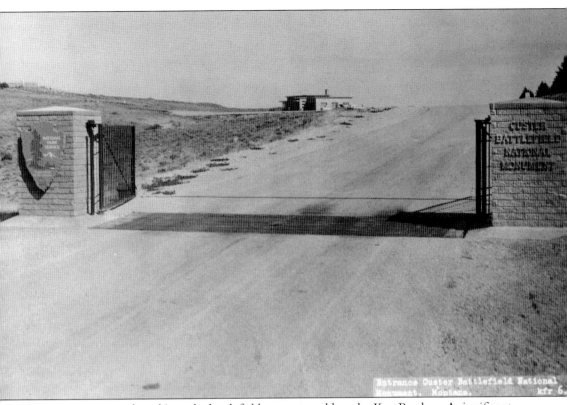

The new entrance and road into the battlefield are captured here by Ken Roahen. A significant change today is the addition of a kiosk, where fees are collected to enter the park.

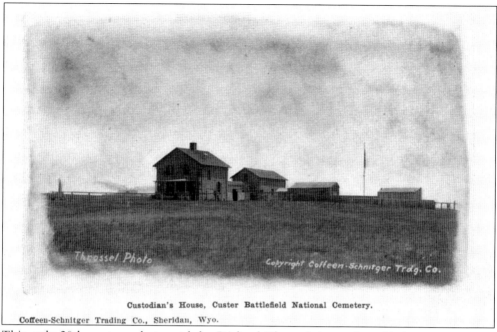

Custodian's House, Custer Battlefield National Cemetery.

Coffeen-Schnitger Trading Co., Sheridan, Wyo.

This early-20th-century photograph by Richard Throssel shows the gabled two-story stone lodge built in 1894–1895 to house the superintendent and his family. The outbuildings and stable were added soon after. This was also the headquarters for the administration of the site, first by the War Department and later by the National Park Service.

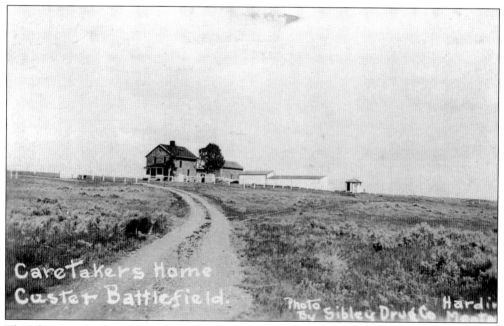

This photograph of the Stone House in the distance shows just how isolated the site was for the superintendent and his family.

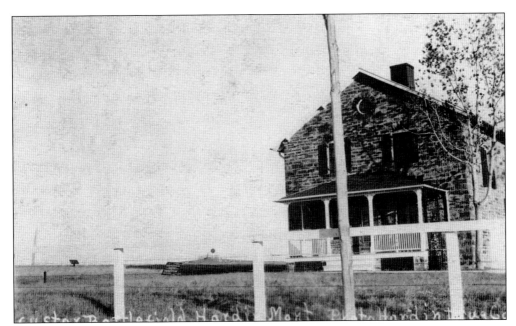

Here one can see a closer view of the Stone House.

The outbuildings of the Stone House are seen here in relation to the national cemetery. Note the lack of vegetation in this period. The superintendents were often referred to by the local Native Americans as "ghost herders," who prevented the spirits of the dead from roaming beyond the cemetery.

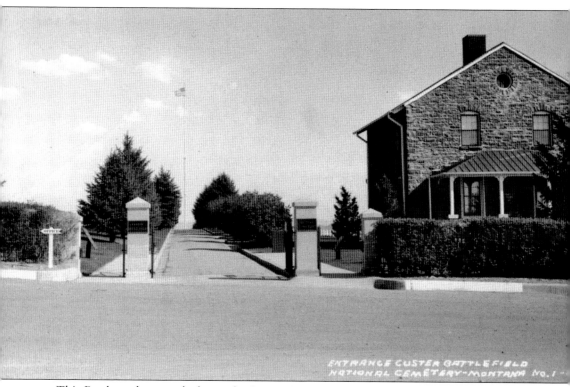

ENTRANCE CUSTER BATTLEFIELD
NATIONAL CEMETERY-MONTANA No.1

This Roahen photograph shows the Stone House as it looks today. For a number of years, it was not longer used as a residence for the superintendent or for administration. There were even stories about sightings of ghosts. Today it has been renovated and serves as the office of the battlefield historian as well as the location of the White Swan Library, named for the Crow scout wounded in the valley fight with Reno. The library contains the battlefield's extensive book collection. Many researchers come to the battlefield each year to do research.

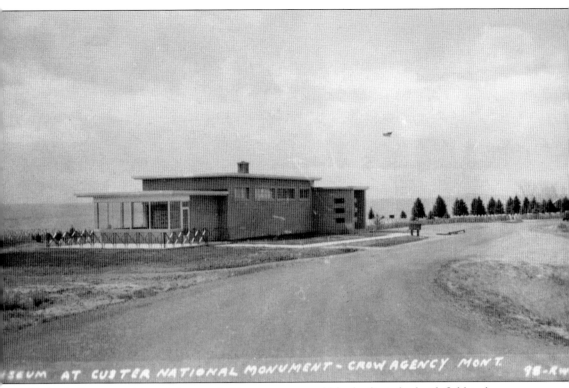

SEUM AT CUSTER NATIONAL MONUMENT - CROW AGENCY MONT. 98-RW

Elizabeth Custer envisioned that a suitable museum would be built at the battlefield to house relics and mementos of Custer's life and the history of the 7th Cavalry. Congress passed legislation to do just that, but it was not until 1950 that the money was approved. The building here was dedicated on June 25, 1952 (the 76th anniversary of the battle). Constructed to display exhibits and offer administrative space, it also houses various important historic collections dealing with the Little Bighorn and the Indian Wars period. With some modifications, it is still in use today.

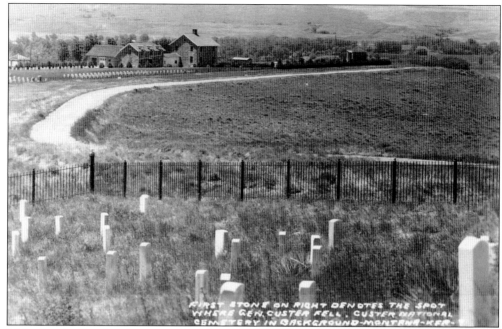

This view by Ken Roahen was taken from Custer Hill and shows the area where the Visitors' Center would be located.

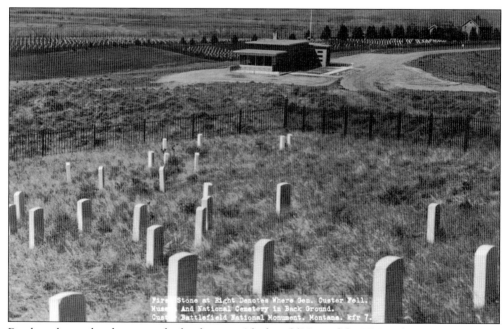

Roahen shows the change to the landscape with the addition of the Visitors' Center.

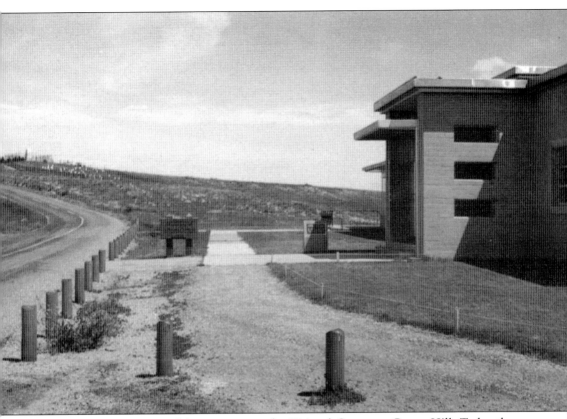

One can see the proximity of the entrance to the Visitors' Center to Custer Hill. Today the National Park Service makes available many interpretive programs here to learn about the battle, its participants, and the causes of the conflict.

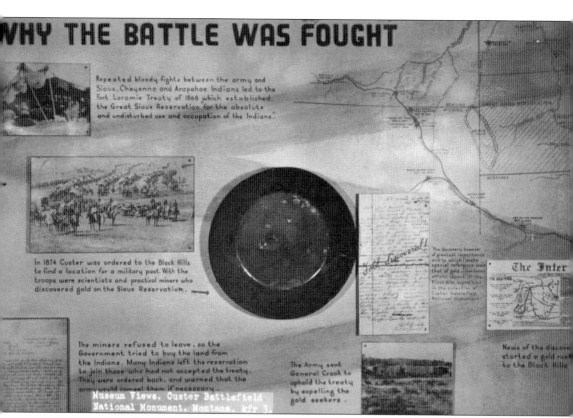

WHY THE BATTLE WAS FOUGHT

Repeated bloody fights between the army and Sioux, Cheyenne and Arapahoe Indians led to the Fort Laramie Treaty of 1868 which established the Great Sioux Reservation for the absolute and undisturbed use and occupation of the Indians.

In 1874 Custer was ordered to the Black Hills to find a location for a military post. With the troops were scientists and practical miners who discovered gold on the Sioux Reservation.

The miners refused to leave, so the Government tried to buy the land from the Indians. Many Indians left the reservation to join those who had not accepted the treaty. They were ordered back, and warned that the army would compel them if necessary.

The Army sent General Crook to uphold the treaty by expelling the gold seekers.

News of the discovery started a gold rush to the Black Hills

The Inter

Museum Views, Custer Battlefield National Monument, Montana. kfr 3.

This exhibit offered visitors the background on why the Battle of the Little Bighorn occurred. It relates the bloody history between the Plains Indians and the government leading to the Fort Laramie Treaty of 1868, which gave the Black Hills in present-day South Dakota to the Sioux, who considered it sacred land. In 1874, Custer led an expedition into the Black Hills where gold was discovered. The gold rush that resulted ultimately led to the reasons why the battle was fought.

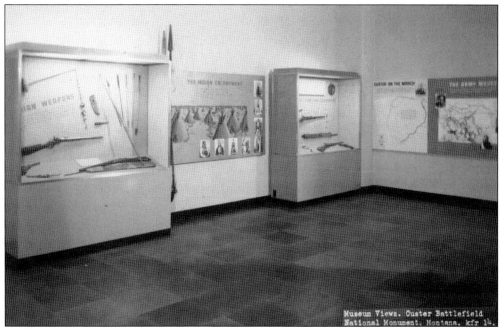

These exhibits depict the progression of interpretation. On the right is a panel showing the three army columns that would move on the Native Americans. To the left of this is another panel focusing upon Custer and the 7th in their march to the Little Bighorn.

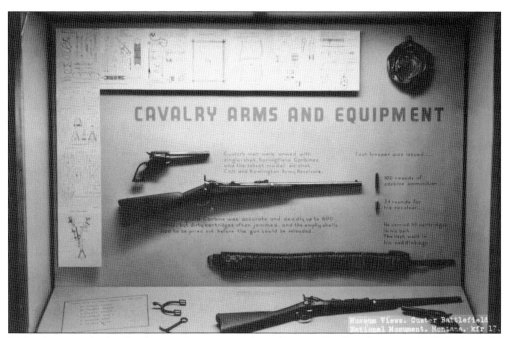

This photograph details the cavalry arms and equipment. Enclosed are an 1873 Springfield carbine and a Colt army revolver, both standard issues for each trooper in the 7th Cavalry.

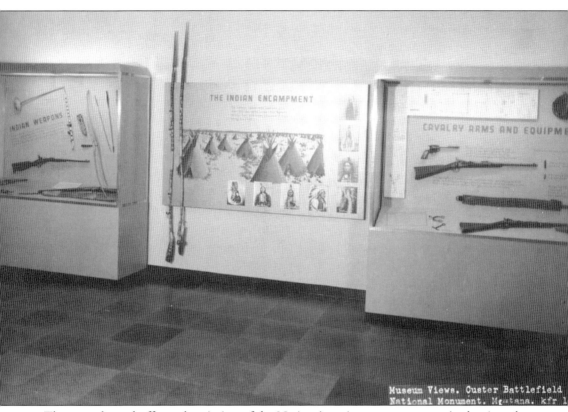

The central panel offers a description of the Native American encampment. At the time these were done, the estimate of the number of warriors was about 4,000 in a 3-mile village. Today historians state that there were less than 3,000 warriors and the village a mile and a half long. The next case on the left displays various Native American weapons, especially a Sioux war club and a skinning or scalping knife. Modern research confirms that the warriors had many more firearms than previously thought.

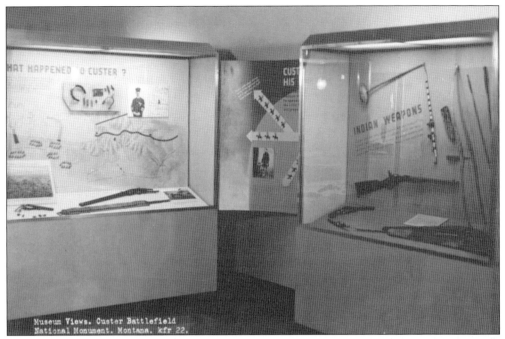

The case on the left explains what happened to Custer in the battle and includes a map that at the time offered a plausible plan of his attack. The case also includes a number of cavalry artifacts found on the route taken by Custer. Today's museum exhibits contain many more artifacts found in the archaeological surveys in the 1980s.

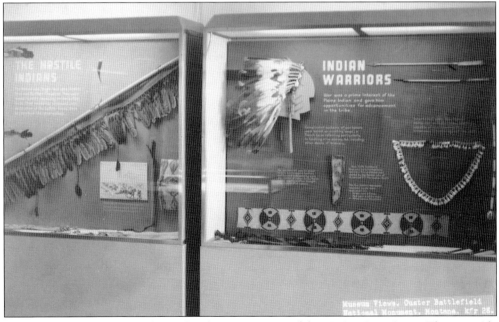

The next two cases truly reflect a dated interpretation of the Native Americans. The very title "hostile" would be seen as one-sided today. Also, the emphasis on the warriors downplays the larger context of Native American life. Rather, today's exhibits emphasize that the Native Americans fought to defend their way of life and culture.

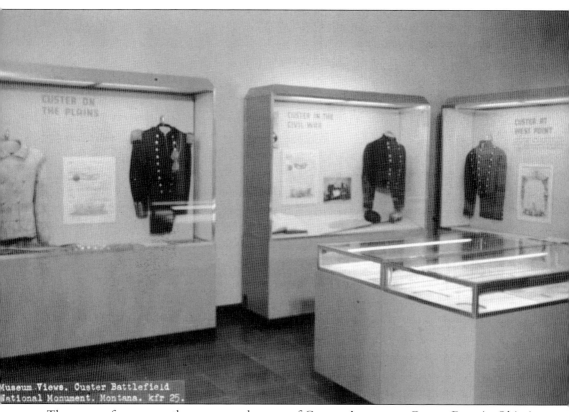

These cases focus upon the person and career of George Armstrong Custer. Born in Ohio in 1839, he attended West Point, graduating in 1861, and quickly rose in the ranks to become one of the youngest generals in American history. The various highlights of his life are, from left to right, Custer's buckskin coat worn on the Plains as well as his dress uniform; his personally designed brigadier general's uniform from the Civil War; and his West Point gray cadet jacket. These continue to be on exhibit in today's museum.

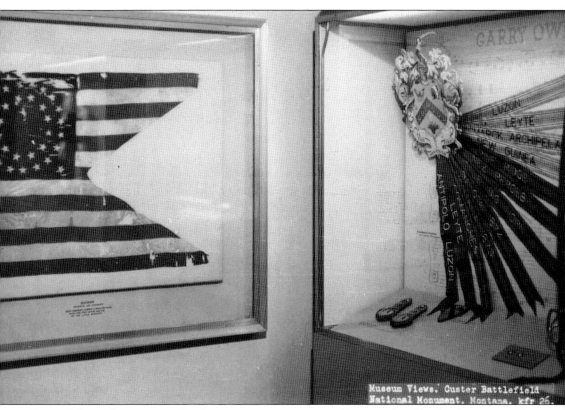

One of the early concerns for the museum was to pay tribute to the 7th Cavalry, past and present. The case on the left displays a sample guidon (the swallowtail flag used by each cavalry company of the period). Using the backdrop of the famous regimental song "Garryowen," the case on the right shows the 7th's service from the Plains to Korea. In subsequent years, with the focus away from honoring the 7th Calvary alone, these exhibits were omitted.

This photograph shows a detailed diorama of the retreat of Maj. Marcus Reno's troops from the valley, showing well the drama and terror of the soldiers fleeing from the warriors.

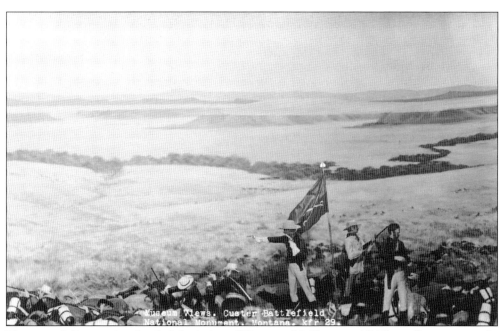

The second diorama is a detailed depiction of Custer at his "last stand." These dioramas remain popular exhibits in the Visitors' Center today.

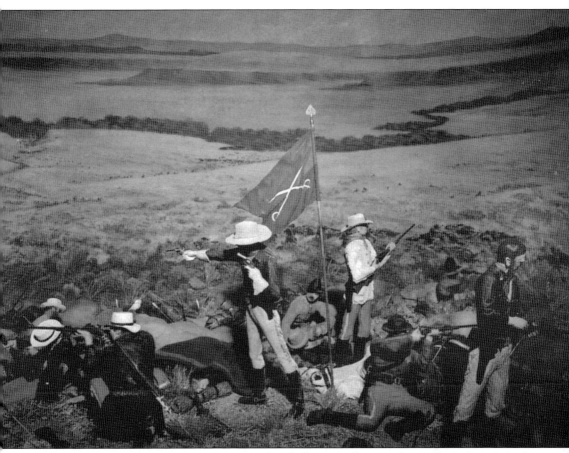

A close-up of the diorama captures many details from the historical record. A short-haired George Custer is just left of the flag, accurately depicted without his buckskin coat and brandishing his English bulldog revolvers. Capt. Tom Custer is just right of the flag. Also shown is Lt. W. W. Cooke with his famous long whiskers. The flag is Custer's red-and-blue personal guidon. Yet this diorama, like all images of the "last stand," will always be subject to the artist's imagination.

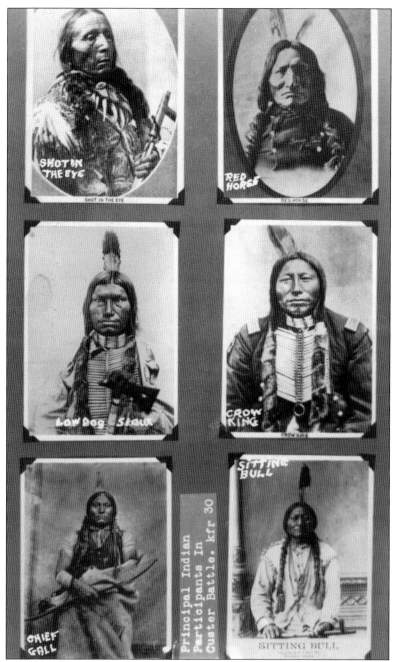

This display shows photographs of the various tribal leaders who fought at the Little Bighorn. Their role was as leaders of their respective bands who would guide the warriors by inspiration and fighting ability. The overall spiritual leader was Sitting Bull (lower right), whose vision and determination to resist the government would win the day at Little Bighorn but would eventually lead to defeat. On December 15, 1890, Sitting Bull was killed by Native American police sent to arrest him on the Grand River. Note that there is no known photograph of Crazy Horse, the Oglala warrior and chief. After surrendering his band at Fort Robinson, Nebraska, he was stabbed to death resisting arrest on September 5, 1877.

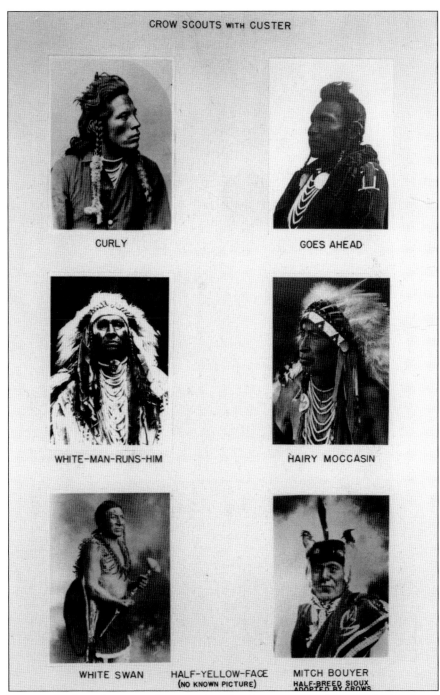

CROW SCOUTS with CUSTER

CURLY

GOES AHEAD

WHITE-MAN-RUNS-HIM

HAIRY MOCCASIN

WHITE SWAN

HALF-YELLOW-FACE
(NO KNOWN PICTURE)

MITCH BOUYER
HALF-BREED SIOUX
ADOPTED BY CROWS

Seen here is a display of pictures documenting the Crow scouts who served with Custer. The Crows were longtime enemies of the Sioux, and it was natural for them to work with the government to protect their lands. White Swan (lower left), for whom the battlefield library was named, was seriously wounded in Reno's valley fight. Mitch Bouyer (lower right) also died with Custer. Apparently a portion of a skull was found below Custer Hill during archaeological surveys and was identified as that of Bouyer.

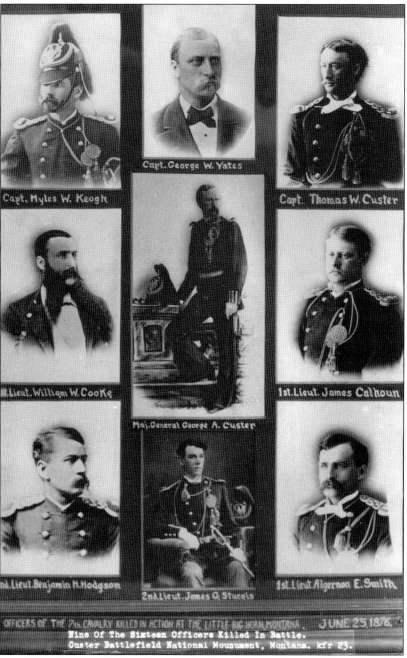

This display shows officers of the 7th Cavalry killed at the Little Bighorn. Of special note is Capt. Myles Keogh (upper left), an Irishman, who had served in the Pope's army in Italy before coming to the Untied States and joining the Union army in the Civil War. Keogh is wearing the dress helmet that was in common use in the late 19th-century U.S. Army. This headgear would not be worn in the field. Also Lt. William Cooke (middle left), a Canadian by birth, was Custer's adjutant. Finally, Lt. James Calhoun (middle right) was married to Custer's sister Margaret. The Custer family suffered the tragedy of losing three sons, a nephew, and a brother-in-law at Little Bighorn.

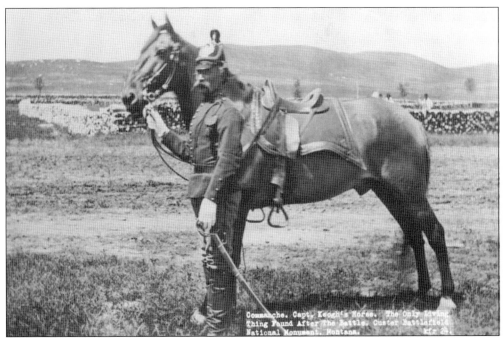

This is Comanche, the mount of Capt. Myles Keogh of Company I and renowned as the "only" survivor of Custer's five companies. He became the mascot and enduring symbol of the 7th Cavalry at Little Bighorn. Other cavalry horses did survive the battle, though, being captured by the Native Americans.

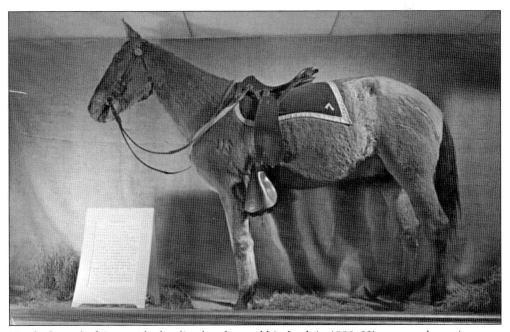

Yet the legend of Comanche has lived on beyond his death in 1890. His mounted remains, seen here, are a popular exhibit at the Museum of Natural History in Lawrence, Kansas.

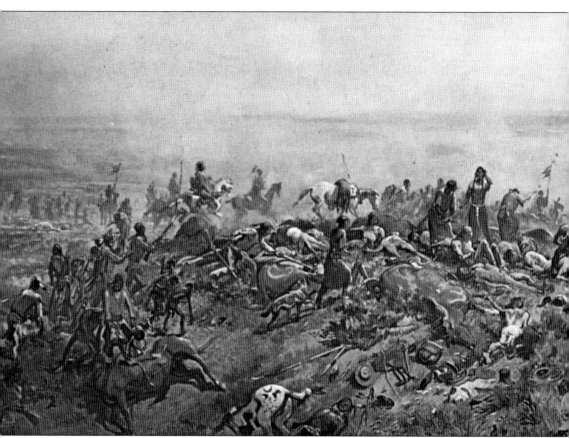

Montana artist J. K. Ralston often used the Little Bighorn as a subject. His monumental work *After the Battle* depicts 39 incidents relating to the Native Americans scalping and robbing Custer's dead. Custer is seen near the center, his body leaning against another with two Indian women standing over him. Sitting Bull had warned his people not to disturb the bodies of

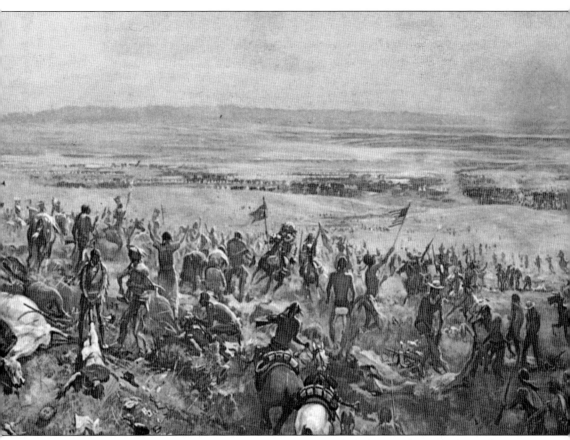

the dead troopers or their possessions, but most disregarded this. Scalping and mutilations were common to the Plains tribes both in expressing outrage towards their enemies, as well as to deprive them of full bodies in the afterlife. This painting continues to be displayed in the Visitors' Center today.

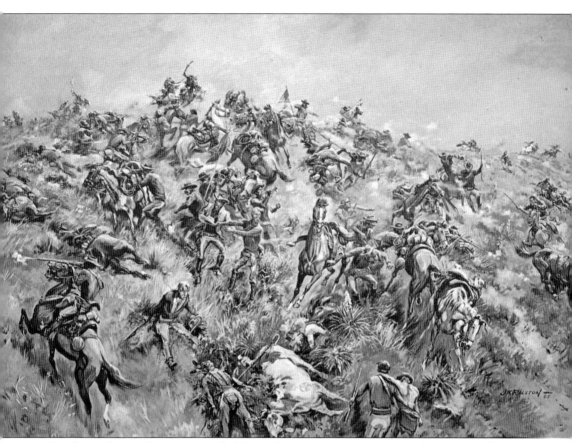

Another Ralston oil painting, *Call of the Bugle*, shows Custer gathering the survivors for the last stand. It was commissioned by the Custer Battlefield Historical and Museum Association and can be viewed in the Visitors' Center today.

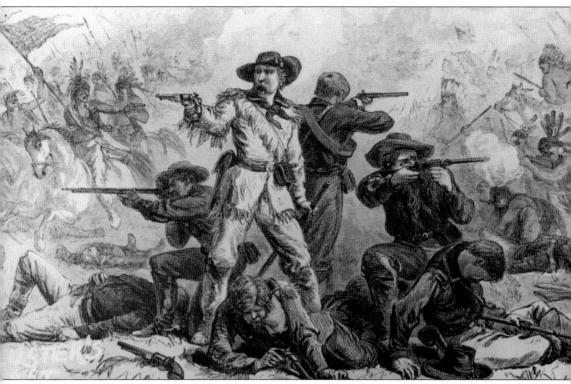

This illustration by Alfred Waud was the first image of the battle published in Frederick Whittaker's 1876 *A Complete Life of Gen. G. A. Custer*. As with most battle art, it is not very accurate, mistakenly showing Custer in buckskins and using the wrong weapons. Still, it captures the desperation of Custer's doomed men. It would serve as a basis for countless paintings, woodcuts, sketches, and sculptures.

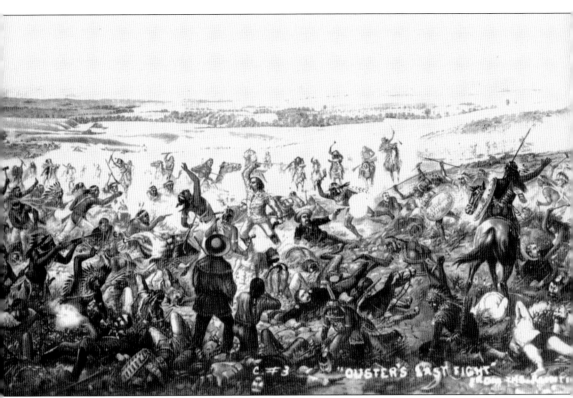

Probably the most recognized image of the battle is "Custer's Last Fight" by Otto Becker. This lithograph was originally produced in 1896 by Anheuser-Busch. Based upon an earlier painting by Cassilly Adams acquired by the brewery, it was widely distributed as advertising. Still, while good at selling beer, it is poor history. Custer did not wear long hair at the battle, or wear buckskins, and did not carry a saber. Also, the various warriors seem to look more like African natives than American Indians.

Six

A Controversial Legacy

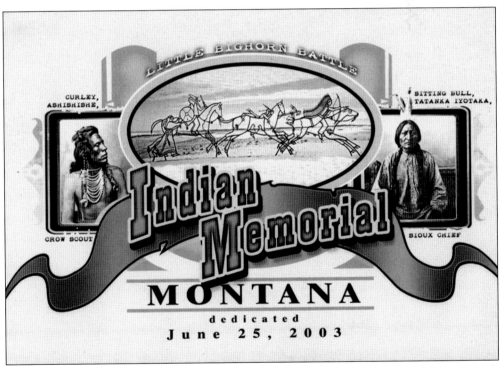

For over a century, the emphasis at the battlefield focused more upon Custer and the 7th Cavalry than the Native American victors. During the centennial of the Little Bighorn in 1976, Native American activists demonstrated to demand more recognition for their part of the story. Eventually the National Park Service responded, calling for a Native American memorial on the site. Another controversial action was to change the name from Custer Battlefield to Little Bighorn Battlefield National Monument. After design competition and fund-raising efforts, the dream of this Indian Memorial became a reality. Dedicated on June 25, 2003, its theme is "Peace through Unity." Located within view of the 7th Cavalry Memorial, its circular form opens to a "spirit gate" to welcome all. It commemorates the Native American warriors who fought both with the army and those who fought against it.

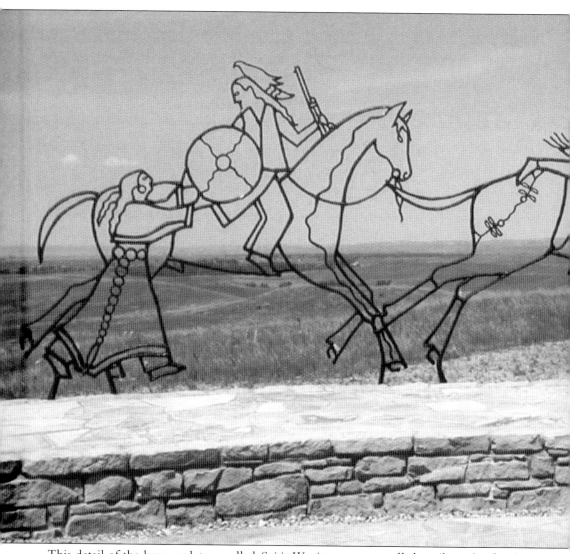

This detail of the large sculpture called *Spirit Warriors* represents all the tribes who fought in the battle. The silhouettes of three mounted warriors along with a woman stand in beautiful

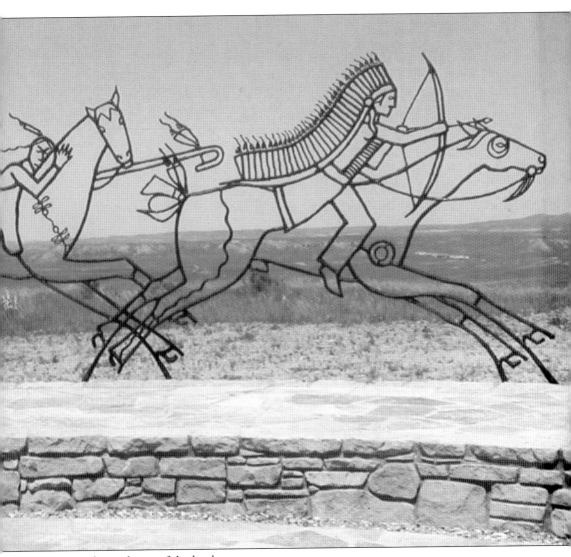

contrast to the starkness of the land.

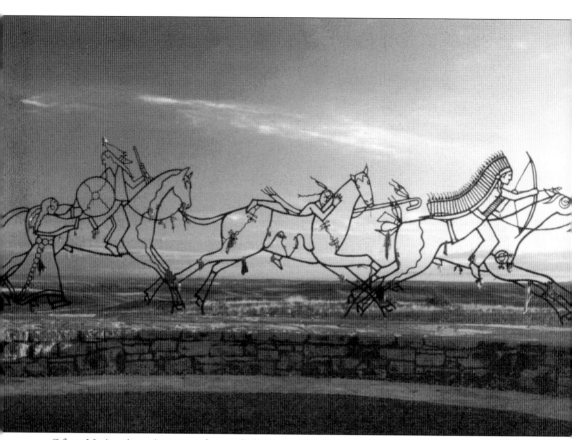

Often Native Americans conduct tribal ceremonies here, leaving offerings as shown. Pictures and words along the walls of the monument tell their stories.

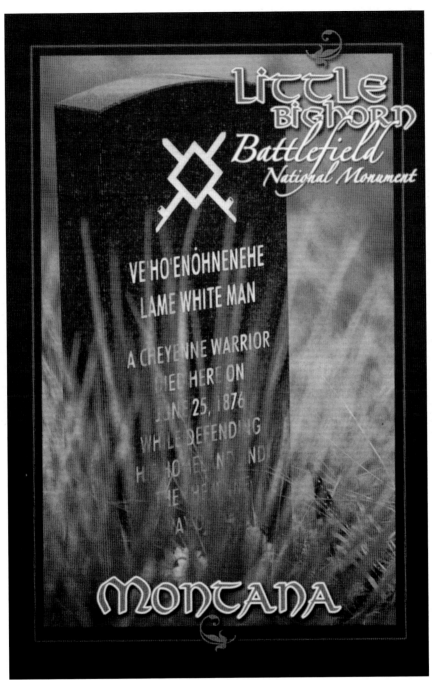

Another feature that has furthered the Native American story is the addition of red granite markers to honor Native American casualties on the battlefield, complementing those for the soldiers. This marker is for Lame White Man, a Southern Cheyenne, who led a charge against Company C, forcing them back toward Calhoun Hill. In the charge, Lame White Man died. In 1925, his daughter wrote to the superintendent asking for a marker to be placed where he died, but she received no response. In 1956, a wood marker was placed on the road, now replaced by this stone.

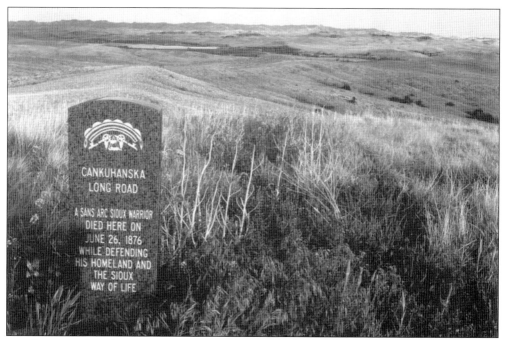

Another example is this photograph by Jim Eshleman of the marker for Long Road, a young Sans Arc warrior, who was killed rushing toward the soldier line on June 26 in the hilltop fight.

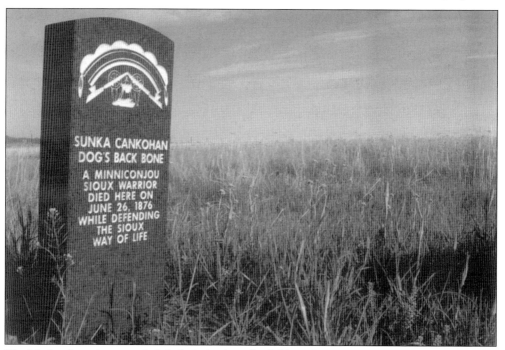

The Native Americans rarely left their dead on the field. Still, they would set up small rock piles to remember the site. This photograph by Jim Eshleman shows the marker for Minneconjou warrior Dog's Back Bone, dedicated in 2003. Just as he warned his tribesmen to be careful, he was shot in the forehead by the soldiers of Reno and Benteen on June 26.

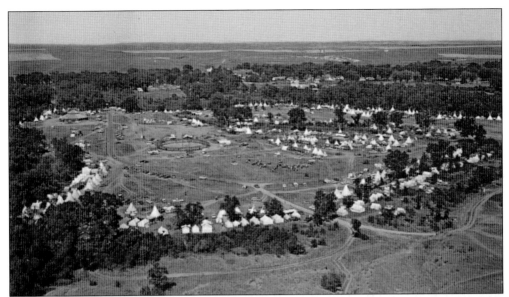

The Little Bighorn Battlefield National Monument is surrounded by the Crow reservation. They take great pride in celebrating their heritage. This is especially true during every third week of August, when the area near the battlefield becomes the "Tipi Capital of the World" and American and Canadian Indians gather for the Crow celebration and rodeo.

This contemporary view shows the Apsaalooke (Crow) Nation Veterans' Park at Crow Agency, Montana. The park was constructed to honor all the Crow warriors past and present who fought and even died to protect their Crow homeland. This includes the scouts who served with Custer as well as their honored veterans serving the U.S. military even today.

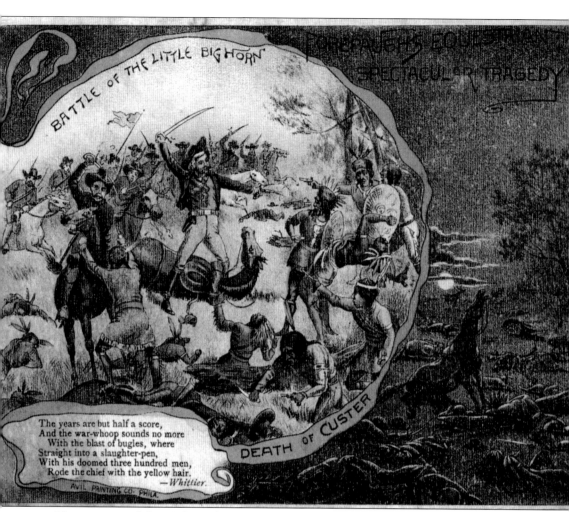

The memory of the Little Bighorn remained in the public mind because its story became a drama to be reenacted. This card of the famous Forepaugh's Wild West Show features Custer's last stand. Buffalo Bill would offer a similar event as well as other Wild West shows.

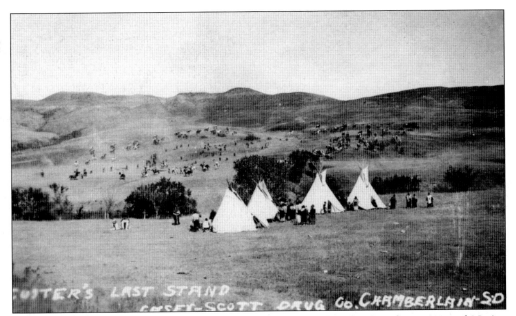

Military groups and private groups also did reenactments of the battle, often using real Native Americans, such as this one in Chamberlain, South Dakota.

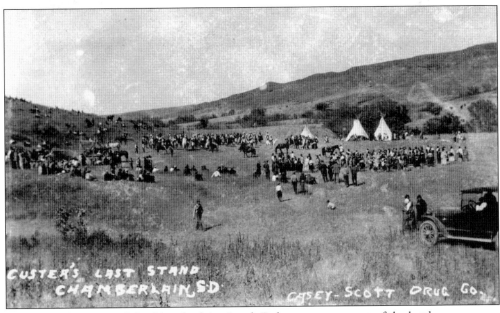

This is another view of the Chamberlain, South Dakota, reenactment of the battle.

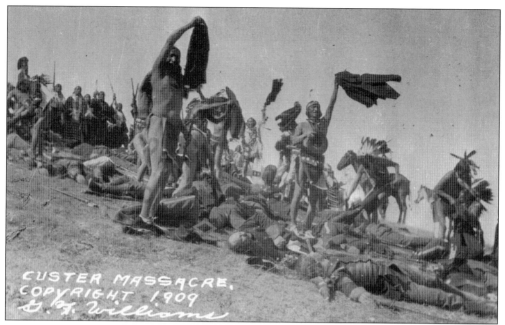

Movies were also used as a means to tell the Little Bighorn story, as in this photograph from an unidentified 1909 film. Over the years, many have done the same. The "last stand" in the 1970 *Little Big Man* was actually made on the battlefield.

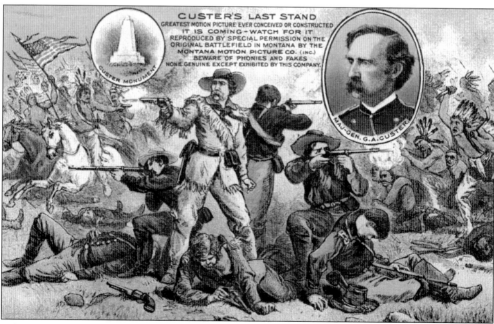

Advertisements like this one for an early movie about the Battle of Little Bighorn used the battlefield to assure the viewer of its historical accuracy. Still, in fact, all films made on the battle, like most art on the topic, are plagued with errors.

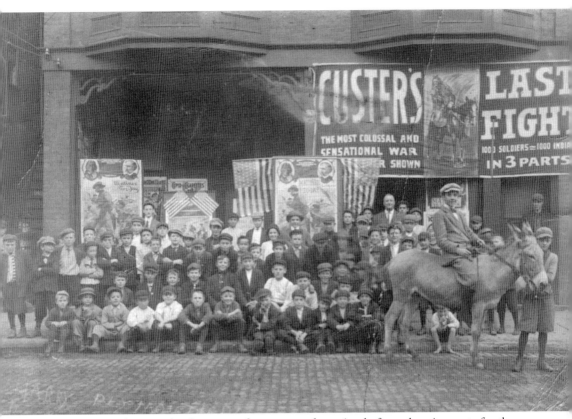

This is a very rare photograph of a group of young people posing before advertisements for the 1912 silent movie *Custer's Last Fight*, directed by Thomas Ince and starring Francis Ford (brother of director John Ford) as Custer. The battle would be a popular subject for filmmakers.

For many years, the nearby town of Hardin, Montana, has done a Custer's Last Stand Reenactment that has become a popular summer event in late June.

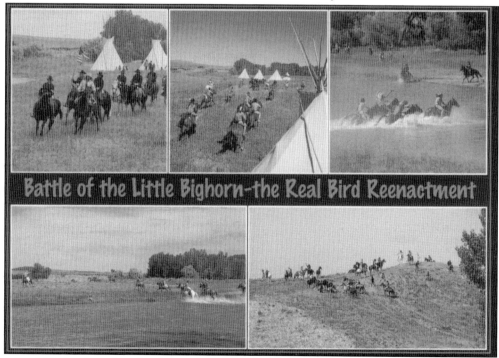

A local Native American family on the reservation has also conducted a reenactment on their property at Medicine Tail Coulee.

Souvenir Folder of
CUSTER
BATTLEFIELD,
Commemorating the Anniversary of the Custer Massacre in 1876.

Gen. Geo. A. Custer.

M _____

© J. L. Robbins.
Published by J. L. Robbins Co., Spokane, Wash.

Much has changed over the years in the interpretation of the Battle of the Little Bighorn. No longer termed a "massacre" by Native Americans of soldiers, the event is now understood in terms of a "clash of cultures," a fight to defend a way of life.

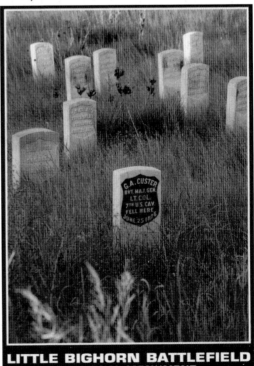

LITTLE BIGHORN BATTLEFIELD
NATIONAL MONUMENT

George Armstrong Custer was 36 years old at the time of his death. The legend that surrounds him was forged not only in his own lifetime but also by his devoted wife, "Libbie," who wrote three books about her life with the general. She would outlive him for 57 years, dying in 1933 just short of her 91st birthday.

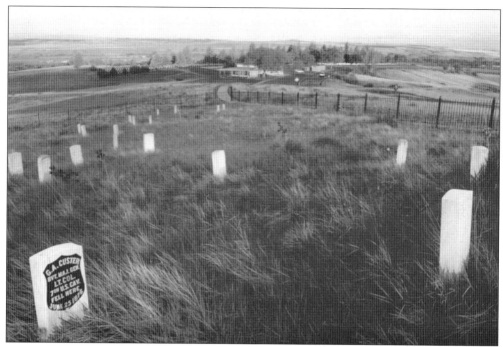

Jim Eshleman, in a striking photograph, shows Custer Hill and the battlefield as it looks today.

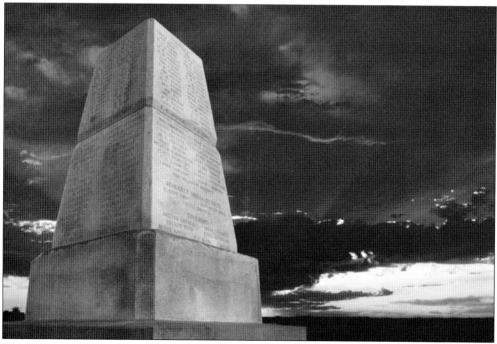

This image by Jim Eshleman of the 7th Cavalry Memorial shows the tragedy and triumph of the Little Bighorn. The 7th Calvary Memorial stands against the Montana sky forever a reminder of the heroism and tragedy of the Little Bighorn.

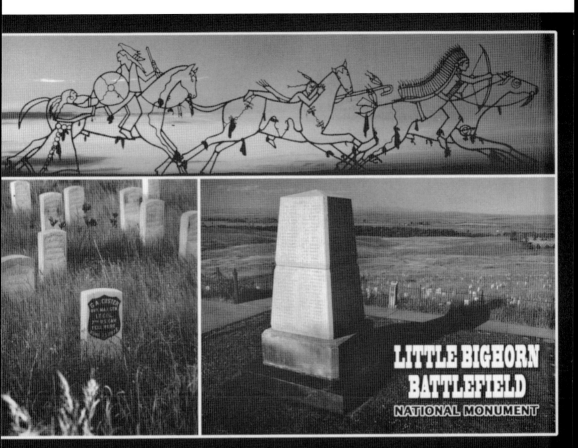

LITTLE BIGHORN
BATTLEFIELD
NATIONAL MONUMENT

Much has changed here over the years, both in the locale and its ongoing interpretation. Stakes placed at barely covered graves led to marble headstones honoring the soldiers. But what can be said of the victors? With the Indian Memorial, there is now a balance of honor and remembrance. This is fitting. Yet it will never fully end the ongoing controversy that makes the Battle of the Little Bighorn a legend of worldwide proportions.

ACROSS AMERICA, PEOPLE ARE DISCOVERING SOMETHING WONDERFUL. *THEIR HERITAGE.*

Arcadia Publishing is the leading local history publisher in the United States. With more than 4,000 titles in print and hundreds of new titles released every year, Arcadia has extensive specialized experience chronicling the history of communities and celebrating America's hidden stories, bringing to life the people, places, and events from the past. To discover the history of other communities across the nation, please visit:

www.arcadiapublishing.com

Customized search tools allow you to find regional history books about the town where you grew up, the cities where your friends and family live, the town where your parents met, or even that retirement spot you've been dreaming about.